D1584562

EDINBURGH
in the 1950s
Ten Years that Changed a City

JACK GILLON,
DAVID McLEAN &
FRASER PARKINSON

AMBERLEY

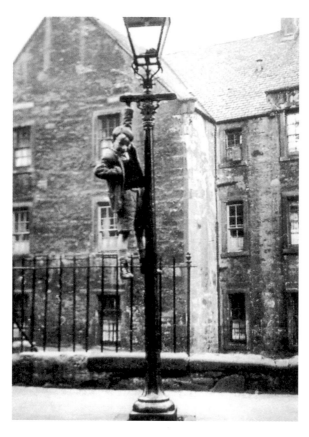

Boys will be boys! A young lad shows off his climbing abilities in Dumbiedykes. The streets of Edinburgh were lit by these distinctive cast-iron street lamps from 1827. Edinburgh's last gas lamp, in Ramsay Gardens, was switched off in 1965. (*Photograph courtesy of Jean Bell & LMA*)

First published 2014

Amberley Publishing
The Hill, Stroud
Gloucestershire, GL5 4EP

www.amberley-books.com

Copyright © Jack Gillon, David McLean & Fraser Parkinson, 2014

The right of Jack Gillon, David McLean & Fraser Parkinson to be identified as the Authors of this work has been asserted in accordance with the Copyrights, Designs and Patents Act 1988.

British Library Cataloguing in Publication Data.
A catalogue record for this book is available from the British Library.

ISBN 978 1 4456 3755 6 (print)
ISBN 978 1 4456 3769 3 (ebook)

Typeset in 10pt on 12pt Sabon.
Typesetting and Origination by Amberley Publishing.
Printed in the UK.

CONTENTS

ACKNOWLEDGEMENTS

We would like to thank a lot of people for help with the book.

Miles Tubb and Heather Robertson of the Living Memory Association (LMA) and their contributors: Bet Adamson, Andrew Vardy, George Hackland, Grace Melrose, Jean Bell, Maggi and Jim Dignall, Sarah Knight, Seonaidh Guthrie, Evelyn Muir and Joan Dougan.

The Living Memory Association (www.livingmemory.org.uk) was established in 1984. It is an Edinburgh-based group that aims to bring people together through reminiscence and oral history work. They encourage people to become actively involved in their community, share their memories, learn from one another, feel valued and respected, and give their knowledge of the past to younger generations.

Alison Stoddart of Edinburgh City Libraries, Patricia Edington of Scotmid Co-operative, Sam Goldblatt and Fiona McPhee at Festival Theatres, John Laird at Murrayfield Ice Rink, Denise Brace at Huntly House Museum, Katie McKenna at the Edinburgh International Festival, and Rachel David at the Royal Edinburgh Military Tattoo were more than helpful in providing information and images.

Particular thanks to Danny Callaghan and Ron Leckie, all the way from California, for their help with pictures and their reminiscences of Edinburgh in the 1950s. Peter Stubbs of Edinphoto (www.edinphoto.org.uk) was instrumental in putting us in touch with Ron and Danny.

The 79,000 friends of the Lost Edinburgh Facebook page (www.facebook.com/lostedinburgh) are a constant source of inspiration. Special thanks to Lost Edinburgh friend George Angus for his contribution of images from the period.

Many of the images are sourced from online sales of images taken by anonymous visitors and locals during the 1950s. We thank them for finding Edinburgh interesting enough to take these pictures.

Sian Griffiths at Amberley Publishing was always available for advice and encouragement.

Last, but not least, our patient and long-suffering wives, who tolerate our sometimes obsessive interest in all things 'old Edinburgh'.

Jack, David & Fraser

INTRODUCTION

Britain changed definitively and dramatically in the 1950s in ways that shaped the way we now live, but it was a slow start. The Festival of Britain, in 1951, is often cited as marking the start of the new post-war era, and it held out promises of brighter things to come – sometime in the future. However, at the time, the country was still recovering from the depredations of the Second World War. Rationing had got even stricter after the end of the war, with bread and potatoes being added to the items in short supply and the meat ration cut to 3 ounces per week in 1950. There was some relaxation by the start of the 1950s, but sweets and sugar did not come off the ration until 1953. Unemployment was also high and there was an acute shortage of decent housing – yet in few years a transformation had occurred.

By 1957, Harold MacMillan was famously able to affirm that Britain 'had never had it so good'; this seemed to epitomise the optimism of the period, and many in a newly affluent Britain would have agreed with him. A housing boom was underway, the economy was thriving, pay was good and unemployment low. The health of the nation had also improved since the introduction of the National Health Service in 1948, which provided free access to all forms of medical treatment. The introduction of vaccinations for tuberculosis in 1953, and polio in 1955, eradicated the fear of these terrible diseases. In these conditions, expectations of lifestyle were rapidly rising and there was an expansion in consumerism.

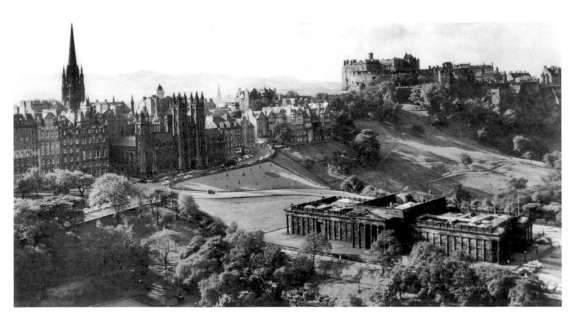

Classic composition of Edinburgh Castle and the Old Town from the upper reaches of the Scott Monument. One of the few views of Edinburgh that has barely changed in the last century. The National Gallery is soot-blackened and has no railing around its boundary. The bowling green in the gardens is just visible.

Ownership of modern household appliances had been held back by the economic impact of the war, and there was unprecedented demand for new modern devices: washing machines, electric fires, vacuum cleaners, transistor radios, televisions, fridges and freezers, although even in the late 1950s only a third of British homes had any kind of washing machine. The demand for car ownership and housing was also starting to reshape towns and cities with new roads, housing estates, tower blocks and supermarkets.

The dramatic economic growth and increased leisure time paved the way for a new form of youth culture – the teenager was born. Young people had more money in their pockets and music, film and leisure activities were geared towards them – often resulting in a degree of shock from the older generation. The age of the crooners was passing, and the skiffle music of Lonnie Donegan and the rock 'n' roll of Bill Haley, Elvis Presley and Cliff Richard were revolutionary and dangerous. When *Rock Around the Clock* reached Britain in 1955, there was much concerned talk of rising 'juvenile delinquency' and 'rock 'n' roll riots'.

Britain lost its empire in the 1950s and seemed a diminished power. Nonetheless, it became the third state in the world to gain the atomic bomb in 1952, followed by the hydrogen bomb in 1957. The world was still a turbulent place and, throughout the 1950s, all eighteen-year-old men were liable for call-up to the military. The Cold War and the threat of nuclear annihilation hung over the world, and National Service and the Campaign for Nuclear Disarmament were as much part of life in the 1950s as rock 'n' roll.

In Edinburgh, the 1950s marked the end of an era, for good and for bad. It was a time when slum housing was a blight on many people's lives, but the comradeship of wartime was still evident and there was a real sense of community that was lost in the move to sparkling modern homes in the new housing estates. People still used the trams to travel to work in the many factories or make trips for a day of fun at Portobello. It was a glory period for the local football teams, and a night at the pictures or out dancing was a weekly event. There was still the horse-drawn milk float and children played in streets that were lit by gas.

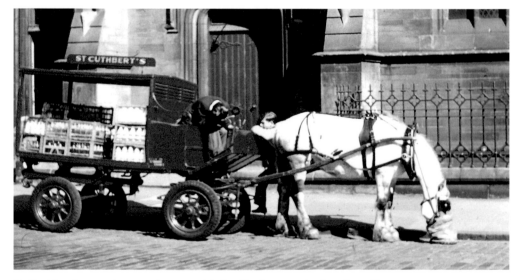

St Cuthbert's store horse enjoys a quick feed before continuing the milk run.

1

Changing Face of the City

For a long period, Edinburgh was the largest and most important city in Britain after London and Dublin. However, while the Industrial Revolution produced explosive growth in manufacturing cities such as Leeds, Liverpool, Sheffield and Glasgow, Edinburgh avoided much of this frantic growth; being of less strategic importance during the Second World War, it also escaped major bomb damage. However, post-war, the city was in an increasingly shabby condition and traffic was becoming a problem. Change and improvement were the order of the time.

This was reflected in the Civic Survey and Plan for the City and Royal Burgh of Edinburgh. Published on 1 January 1949, the plan was prepared by the eminent planning experts, Patrick Abercrombie and Derek Plumstead, and is generally known as the Abercrombie Plan. Its intention was to formalise the city's approach to planning and guide future development.

The preamble to the plan says, 'A Plan for Edinburgh must needs be a hazardous undertaking: there can be few cities towards which the inhabitants display a fiercer loyalty or deeper affection ... Even its blemishes are venerated ... The planner who dares to propose improvements must go warily...'

However, despite this claim, the plan was a big book packed with survey information and even bigger ideas for change, and in today's terms would appear less than wary. Abercrombie himself noted that the plan was potentially overbold.

The plan included proposals for the complete clearance of Leith to create an industrial zone; a freight railway under the Meadows; the creation of new communities in areas such as Wester Hailes and the rebuilding of Princes Street, under which a second road would be built as part of a new road and rail system.

Further ambitious road proposals included a Bridges Bypass, a dual carriageway sweeping around the eastern part of the city centre with tunnels through the Old Town and under Calton Hill, and a Milton Road Bypass with a new road carved through Holyrood Park. The plan did anticipate the need for a City Bypass – the suggested route broadly following the line of the road that opened forty years later.

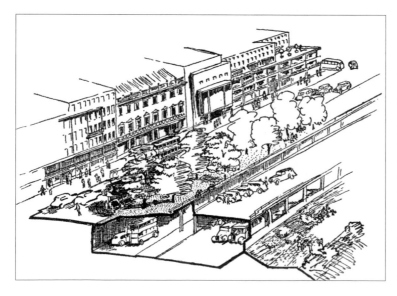

Proposals for Princes Street included the creation of three separate decks. Princes Street at the upper level was to be a service road with all traffic diverted from it. The middle level in Princes Street Gardens was a car park and promenade area, with traffic restricted to a tunnel a level below.

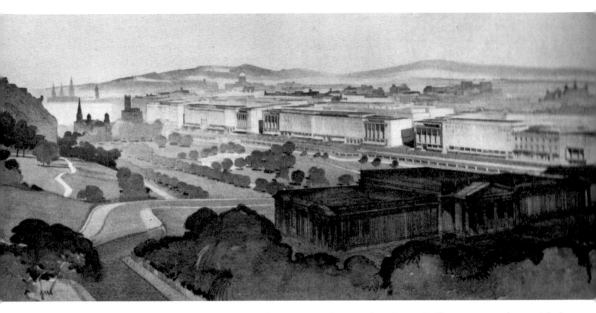

Proposals for Princes Street, showing how the 'ugly confusion of styles and silhouettes can be avoided and an overall composition appreciated'.

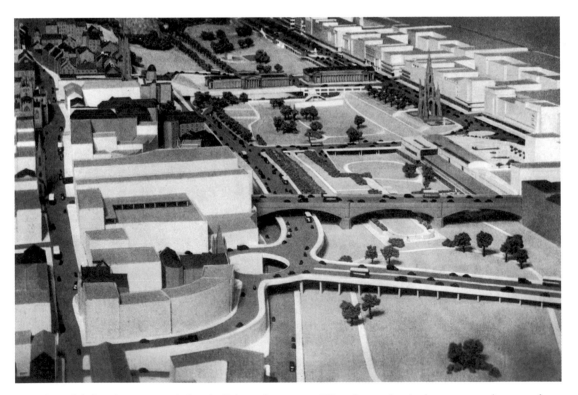

A model showing proposals for the Princes Street area. Waverley station is shown covered over to form garden terraces. The North Bridge Bypass is shown linked to the Mound by a Princes Street Bypass road.

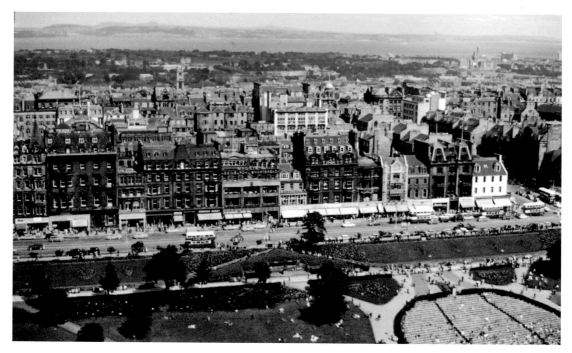

View of Princes Street from the castle. The non-uniform Victorian buildings are clearly shown in this photograph. It was also a time when parking on Princes Street was allowed.

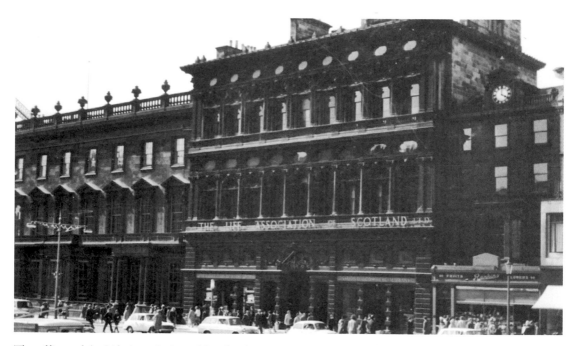

The offices of the Life Association of Scotland on Princes Street were a fine example of Italian-inspired architecture by David Rhind. It was redeveloped in 1967/68 with the idea of creating uniformity and a first-floor-level walkway.

The idea of demolishing existing buildings in Princes Street to restore uniformity was taken up, in 1954, by the Princes Street Panel, which supported the rebuilding of the street from end to end with first-floor balconies that would eventually form a continuous elevated walkway. However, it was in the following decade that the redevelopment of Princes Street got underway, with the demolition of Victorian buildings such as the Life Association building office and the New Club.

In contrast with the English cities where Abercrombie had previously worked, Edinburgh had suffered very little war damage. This was a critical difference when it came to the public's response to his proposals, and they were widely criticised. They were described by one correspondent to the *Scotsman* as a 'sacrilegious outrage', and most were ultimately abandoned.

Despite many ambitious plans, Edinburgh escaped the kind of projects that affected other cities: no motorways have ravaged the city centre and a wealth of historic buildings survived. This was due, in some degree, to the innate conservative nature of the city, articulate pressure groups, the outstanding heritage value of the city centre and the topography that made many of the road proposals unworkable.

The Abercrombie Plan identified that almost 250,000 people, half the population of Edinburgh at the time, were living in outmoded property containing inadequate sanitary facilities. Abercrombie recognised that overcrowding and bad housing conditions presented the most urgent problem, and recommended that any new housing development should be carried out to relieve these conditions.

The Edinburgh slums of the 1950s were dreadful, beyond doubt, and in addition to the appalling accommodation, infestations of vermin and outbreaks of dysentery were common. In 1951, in the two central wards – St Giles and Holyrood – well over half the dwellings contained only one or two rooms; 4,000 people occupied 1,776 single rooms and almost 2,500 were living more than three to a room.

Baths were a rarity, possessed by only 2,165 households out of 13,810; almost half had no separate WC. Personal hygiene options for most would have involved a tin bath or a visit to a local swimming pool, where plunge baths were available for a small charge. Washing of clothes in the 1950s, before the days of household machines, would have involved a visit to a local washhouse.

In the 1950s, the streets in the St Leonard/Dumbiedykes area were considered for redevelopment. Beaumont Place included the 'Penny Tenement', whose owner tried to sell it for a penny in 1953 to demonstrate the burden on landlords caused by rent controls. No one came forward with a penny and it was offered free to the council, who also declined. On 21 November 1958 at 5 a.m., part of the building collapsed, fortunately with no fatalities, but the tenement had to be evacuated and temporary accommodation provided.

The collapse of the Penny Tenement caused considerable reverberations, to the extent that questions were asked in Parliament about the adequacy of existing legislation relating to slum clearance. The incident received wide publicity, which included a *Panorama* programme, in which a young girl talked about the mice that ran over her feet in her bed.

It focused attention on Edinburgh's slums and was an event that those calling for renewal had been waiting for. In December 1959, Edinburgh councillors made a tour of inspection of the slums in the St Leonards area to view the problems first-hand. Two

extensive clearance areas around Carnegie Street were declared shortly afterwards, and a hundred families were immediately moved from dangerous homes and rehoused – the beginning of a major slum-clearance drive. In the early 1960s, 1,030 houses were demolished in the St Leonard's area and an estimated 1,977 people displaced. Slum clearance was also the impetus for major redevelopment in Newhaven, Greenside, Leith and parts of the Old Town.

The Abercrombie Plan had also proposed the demolition of slum housing in the St James Square area to create a new theatre and concert hall. The Square dated from the eighteenth century and had been designed by James Craig, the originator of the plan for the first New Town. The plans for the theatre and concert hall were later abandoned and the Leith Street frontage of St James Square, with its distinctive first-floor terrace, survived the 1950s. However, the Square, along with neighbouring streets, did not survive the comprehensive redevelopment of the 1960s.

The Canongate was a separate burgh from Edinburgh until 1856, with its own identity and character. As late as the 1950s, Canongate dwellers would still refer to 'going up to Edinburgh', although the distance was measured in yards.

In March 1947, part of the historic Morocco Land in the Canongate collapsed in ruins after standing empty for eighteen years. Many other historic buildings in the area were crumbling into ruins through lack of care, attention and restoration; and for the inhabitants of the still occupied properties, historical interest was no compensation for the condition of their homes and lack of basic amenities.

Eighty per cent of all dwellings in the area consisted of one or two rooms. A quarter of all households in the area cooked, ate, slept and carried out the whole business of living in one room. Families in the dwellings with two rooms were in little better state. One room was generally used as a kitchen, dining room and living room, and usually contained a bed, while the second room was used as a bedroom. The WC and water supply was usually shared, which meant that numerous households used the same conveniences.

Family life was difficult for the many large families that occupied such limited accommodation. In one family, two parents with sons aged six and sixteen and three daughters aged three, eleven and twelve lived in two rooms. In another family, the father, mother and small son slept in one bed, while the daughter, aged sixteen, and son, aged thirteen, slept in another.

Most houses were privately owned, but few were occupied by their owners. This multiplicity of ownership by private individuals, many of whom had no means to maintain it, made the development and restoration of the Canongate an expensive and complicated undertaking for the Town Council.

Interventions to clear slums in the Canongate area of the Old Town also had to be treated more sensitively due to its historic importance. In 1952, the architect, Robert Hurd, was commissioned to reconstruct large sections of slum housing in the area. Hurd's three-phase programme included the Tolbooth area, 1953–58; Morocco Land, 1956/57; and Chessel's Court, 1958–66. Hurd's philosophy was to reintroduce a resident population to the Old Town by drawing from all social groups. The architecture was a mixture of preserved blocks and new buildings in a traditional vernacular style that preserved the 'couthy, intimate quality of the street'.

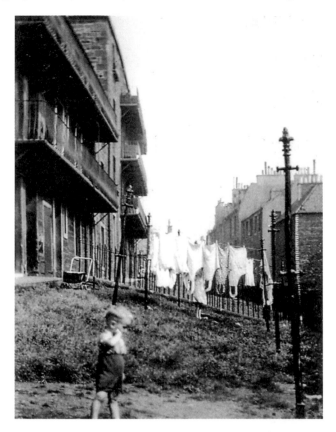

Right: Peter Bottomley in the washing green at No. 38 Dumbiedykes Road. Washing was always taken in at night and never hung out if there was a wedding or a funeral. The pram was used to take laundry to the wash-house. (*Photograph courtesy of of Jean Bell & LMA*)

Below: The steep gradient of Salisbury Street, Dumbiedykes, with Salisbury Crags in the background. These buildings were cleared in the early 1960s. (*Photograph courtesy of Maggi & Jim Dignall and LMA*)

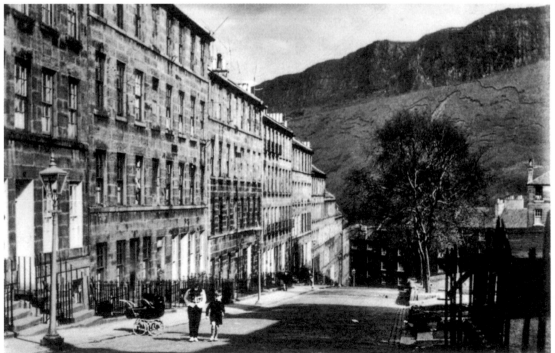

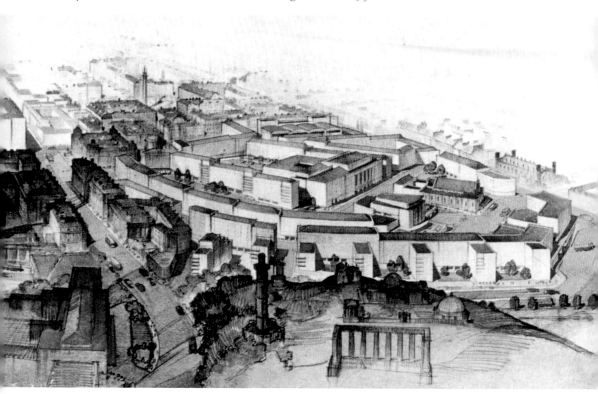

Above: The distinctive elevated terrace of St James Square on Leith Street. The north side of Leith Street and its characterful terrace disappeared in 1969 along with its array of shops.

Opposite above: Model showing the Abercrombie Plan proposals for the redevelopment of St James Square. This proposed plan shows just how little of Leith Street and the St James Quarter was intended to survive. Much of this plan went ahead, although it was considerably revised.

Opposite below: If you stand opposite the Playhouse Theatre at the top of Leith Walk and look up towards Princes Street, this is basically what you would have seen in the 1950s. These buildings have now been replaced by the glass front of the Omni Centre.

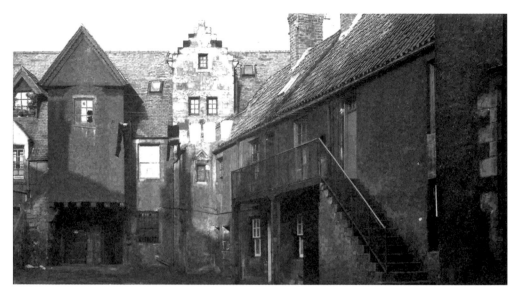

White Horse Close at the foot of the Canongate before its restoration in the 1960s. White Horse Close is home to arguably the most picturesque group of buildings on the Royal Mile. The extensive restoration and reconstruction work carried out by Frank Mears & Partners was a particularly good example of the renewal of a historically important building that had deteriorated into a slum.

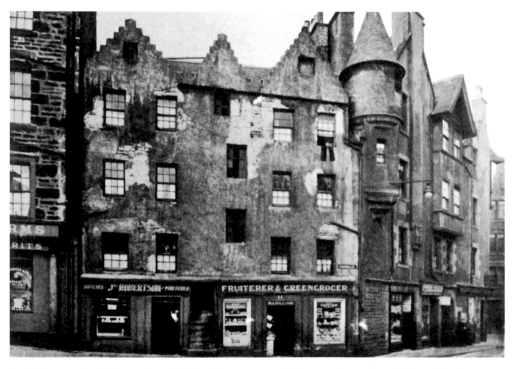

Buildings at the Holyrood end of the Canongate, which were in a state of decay in the 1950s before their sympathetic restoration.

King James IV initiated the development of Newhaven in April 1504. Originally based on the harbour and a small settlement comprising a main street, with small lanes running down to the sea, the King had ambitions to create a Scottish Navy. However, with the exception of the launch of the Great Michael in 1511, Newhaven had only limited involvement with shipbuilding.

Newhaven established itself as a significant harbour for freight and passenger shipping. It was also a busy fishing port and, as with most fishing villages, almost all the families of the village were involved in the industry.

By the late 1950s, the fishing industry was coming to an end. It was recognised that the houses in Newhaven were lacking many modern amenities and were deteriorating into slum conditions. In 1957, Basil Spence started work on piecemeal redevelopment work in the old village of Newhaven in a style that combined modern ideas with themes from the historic fishing village.

Following this, in 1959, Edinburgh Corporation commenced the process of comprehensive redevelopment of Newhaven. Ian G. Lindsay & Partners were appointed as architects in a pioneering attempt to conserve and improve an entire fishing village. Many of the original fishermen's cottages were demolished, and Main Street was the subject of major redevelopment/renovation. This involved the south side being demolished and rebuilt, and the north side being renovated with new deck-access council houses being constructed. This redevelopment, which reflected a national pattern of housing upgrading and demolition, resulted in 200 families being moved out of the village.

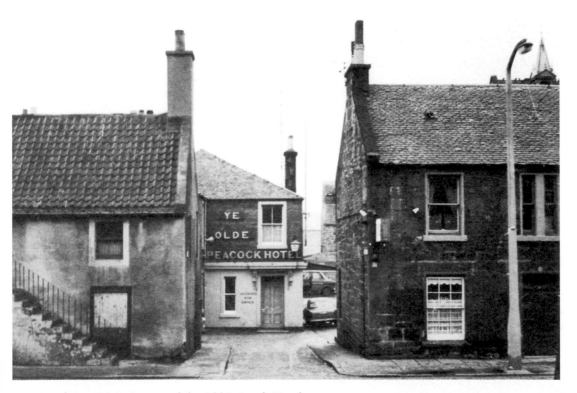

Newhaven Main Street and the Old Peacock Hotel.

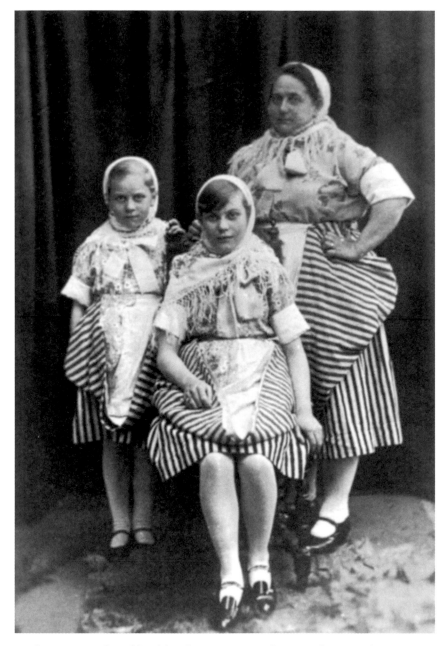

Studio portrait of Hackland family group in Newhaven Fishwives gala costumes. (*George Hackland & LMA*)

The Newhaven fishwives in their colourful costumes carrying a creel of fish on their heads were a familiar sight in Edinburgh for many years as they walked miles to sell their fish. The tradition of the famous Newhaven fishwives continued in the 1950s and Esther Liston, the last working Newhaven fishwife, did not give up the creel until 1976 when she was eighty years old.

The south-east corner of George Square, showing the road leading out of George Square onto Buccleuch Place – approximately where the steps lead down from David Hume Tower to Buccleuch Place nowadays. These magnificent buildings were lost as part of the university redevelopment.

The original townhouses in George Square had been built in the early eighteenth century. It was unique as a planned development that was a predecessor of the New Town. By the 1950s, its condition was poor but, apart from a minor intrusion on the north side, it had retained its original form.

The University of Edinburgh promoted plans to integrate the widely scattered parts of the university and to redevelop George Square and a wider part of the South Side as early as 1945. The university believed that the reconstruction of the square was the only practical solution to their need for expansion. The Abercrombie Plan considered that it was not essential to retain the buildings around George Square and believed that the existing buildings did not deserve 'pride of place in Edinburgh's heritage'.

Fierce debate about the proposals went on throughout the 1950s. Planning permission was granted in 1956, but mounting opposition to the scheme resulted in a public inquiry in 1959. The Historic Buildings Council then indicated that they considered George Square interesting but not comparable to the quality of Charlotte Square, and the technical advice was that they were too dilapidated for reuse. The fate of the historic buildings on George Square was sealed and early in the following decade the redevelopment went ahead.

In the face of a public outcry, modern tower blocks would later replace the old Georgian buildings on George Square. The project was never fully completed but the landmark Parkers' Store building, with its distinctive half-timbered frontage, and other old buildings in the Bristo area were lost.

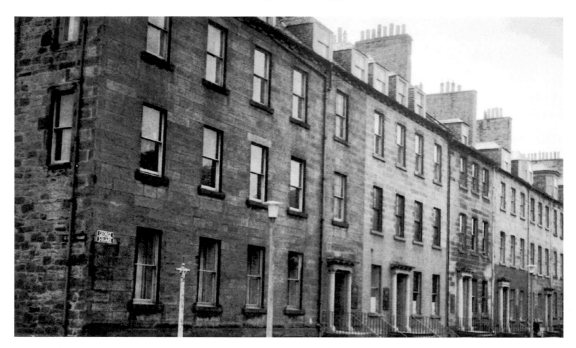

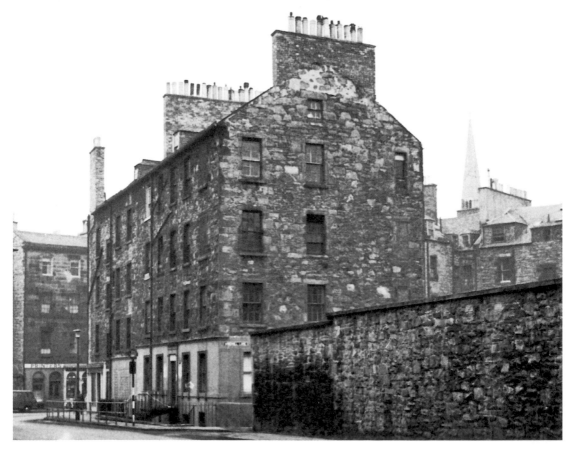

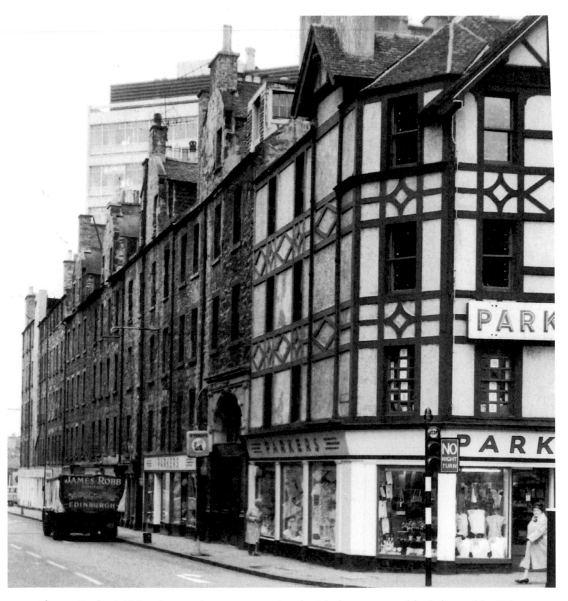

Above: Parker's Triangle was the name associated with the tenement block formed by Bristo Square, Crichton Street and Charles Street, which stood between the present Appleton Tower and Bristo Square. The Triangle took its name from Parker's Stores, which occupied a building with a mock-Tudor frontage – a thin cladding added to the old stone façade – at the corner of Bristo Street and Crichton Street. The buildings were cleared in 1971 and the University Informatics building now occupies the site.

Opposite above: The south side of George Square, which was demolished to make way for the University of Edinburgh library.

Opposite below: Junction of Windmill Lane and Crichton Street. This building was redeveloped for the Appleton Tower.

The great movement to council housing estates on the city margin in the 1950s grew out of the need to clear slums and reduce the high density of city centre areas. There was also a requirement for local authorities to provide adequate housing for all who needed it, regardless of their ability to pay an economic rent. In 1956, the Department of Health for Scotland also made new regulations for minimum room size standards for new houses.

Before the Second World War, two-thirds of the 43,000 new houses in Edinburgh were privately built. In the post-war years, when there was an acute shortage of both building materials, particularly timber, and labour, there was a shift in emphasis to local authority housing to meet the needs of those in most need of new homes. During the 1950s, thousands of houses were built by the local authority, and by 1958, 25 per cent of all dwellings in the city were owned by the Corporation. 1,773 new houses were built at the Inch between 1950 and 1956, 950 at Hyvots Bank from 1953 to 1995, and 1,313 at Gracemount in 1956–62, while the Moredun and Ferniehill areas contributed a substantial quota.

Prefabricated houses were an early answer to the shortages – more than 32,000 were built in Scotland, including 4,000 in Edinburgh. They could be constructed quickly from standard patterns made in central factories and erected with a minimum of time and labour on site. They provided compact homes with an attractive interior design and were well equipped. There was a good-sized living room that had a traditional coal fire, with a back boiler that provided hot water and central heating. The modern bathrooms had heated towel rails and the kitchens had built-in units with the unheard-of luxury of refrigerators. They were also built to a relatively low density, providing generous open space. These amenities and their resemblance to bungalows made them a complete contrast to the conditions in Edinburgh's slum areas and they were much sought-after. The first to be built was a group of around 200 at Muirhouse. Most of the prefabs were demolished in the 1960s to make way for permanent houses at a much greater density, many in tower blocks.

In spite of an extension of the city boundary in 1954, by 1958 suburban land for the big housing estates started to run out. The next step was to start building multistorey blocks of flats. The city's first block was built at Westfield Court, Gorgie, in 1952. These were soon dwarfed by later developments, including a twenty-three-storey block at Muirhouse, twenty-one storeys at Leith Fort, and sixteen storeys at Restalrig and Sighthill.

The movement to the new housing estates in the suburbs resulted in a significant fall in the resident population. In the Holyrood area, this amounted to a loss of 6,000 residents during the 1950s. Younger people with families were the ones that left for the new suburban estates and a mainly ageing population was left behind. People lost contact with friends and family as a result of the shifting population and the spirit of community and good neighbourliness, which even in dour Edinburgh was a feature of the time, was diminished.

Despite enormous additions to the public housing stock of the city in the 1950s, by 1958 there was no sign of overproduction of new homes. This was particularly the case in the private house market. From 1949 to 1958, permission was given for only 9,000 privately-built houses. Private firms were, therefore, able to sell new houses as fast as they were built. In 1958, a new three-apartment house varied from about £1,900 to £2,700, and a six-apartment detached bungalow with a garage was in the range of £4,700. Local authorities could lend funds for house purchase and Edinburgh Corporation loaned £6 million for this purpose between 1945 and 1960.

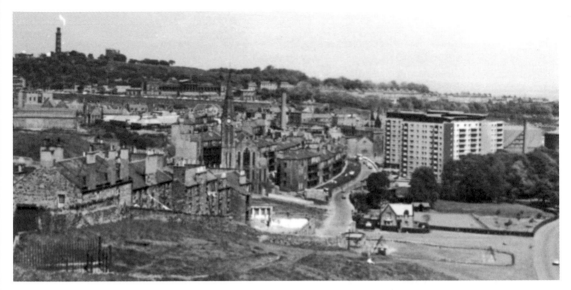

Above: Redevelopment gets underway in Dumbiedykes. The first multistorey flats were occupied in 1963.

Right: Alice Parry with her dog, Jet, in the back garden of her prefab at Sighthill. (*Photograph courtesy Jean Bell & LMA*)

Below: The building boom of the 1950s progresses. A colour shot from 1954 of development progressing at Colinton Mains. (*Photograph courtesy of George Angus*)

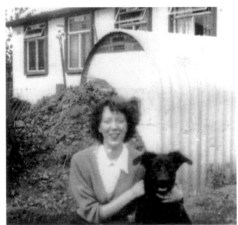

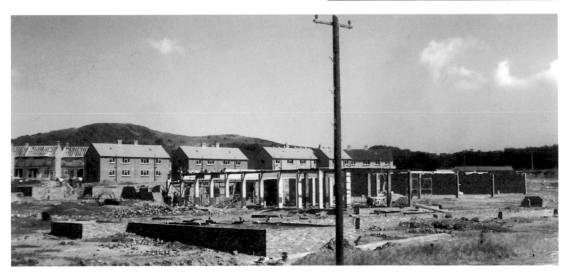

A major fire that destroyed the original C&A Modes department store on Princes Street in 1955 resulted in a dramatic change to the street. The fire on 10 November 1955 was one of the worst that Edinburgh has ever witnessed. Incredibly, it had only been a matter of hours since another spectacular fire had consumed the C. W. Carr & Aikman boot and shoe warehouse on nearby Jeffrey Street – the sheer enormity of both blazes and the short time span between them tested the local fire service to the limit. A new C&A department store rose from the ashes in 1956, located on the same spot as before.

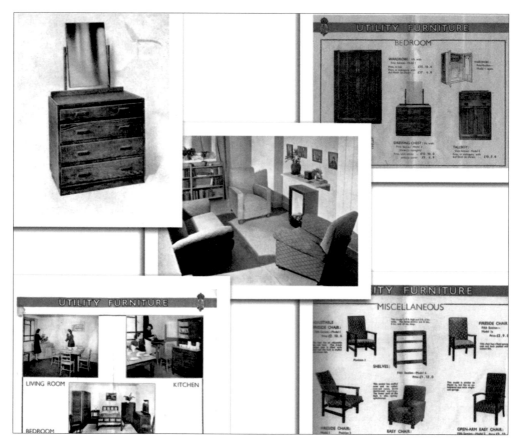

The shortage of wood meant that furnishing a new house in the early 1950s was a challenge due to rationing. Newly married couples were given priority, but the choice was limited to simple and robust, British-manufactured Utility furniture. The Utility Furniture Scheme had been introduced in 1942 to make the best use of the limited supplies of wood and was officially closed in 1952. The following year, the much sought-after G Plan range of stylish furniture for the entire home, which could be purchased piece-by-piece over a number of years, was introduced.

2

THE PEOPLE'S
TRANSPORT –
GETTING AROUND

In 1950, there were just under 2 million cars in Britain, with only 14 per cent of households owning one. By the end of the century, however, this had soared to 21 million.

In 1959, 32,850 cars were registered in Edinburgh – a small number in comparison to today, but parking was still a problem. There were calls for a substantial increase in off-street parking and various proposals were suggested during the 1950s. These included parking on the roof of Waverley Market, double-deck car parks in Queen Street Gardens and using the lower levels of East Princes Street Gardens. The latter reached the stage of a Provisional Order, but was dropped in 1955. The reason given was the Chancellor of the Exchequer's appeal for economy, but the many objections on amenity grounds were a major factor in the decision. Castle Terrace was the site eventually selected for a multistorey car park and this was completed in 1961.

While awaiting the completion of the Castle Terrace car park, motorists were finally subjected to something they had hoped to avoid, when Edinburgh became the first city in Scotland to introduce parking meters. It was debated through the late 1950s and didn't finally happen until August 1962, when meters were installed in George Square, Charlotte Square and St Andrew Square.

Perhaps the most unpopular concept to solve Edinburgh's traffic issues was the idea of an inner ring road, which was first mooted in 1963. The proposal involved a six-lane highway round the centre of Edinburgh, including a route through the Meadows. Warriston Crescent was proposed for demolition and flyovers were proposed for the Calton/Greenside area. This was another idea that eventually fizzled out in the mid-1960s.

A proposal for a traffic roundabout at Randolph Crescent was also the subject of major controversy in the 1950s. The scheme, which was intended to relieve traffic on Princes Street, would have involved infilling basements, the replacement of the old cobbles with asphalt, and the felling of scores of trees. There were energetic protests against the proposals and the issue was featured on a BBC *Panorama* programme. Following an inquiry into the scheme, it was finally rejected in 1960.

Throughout the 1950s, a purchase tax of 33 per cent added to the retail cost of a car put it beyond the means of most. Cycling was the most common form of personal transport during the 1950s and a good public transport system was essential for the commute from the mushrooming suburban housing developments. However, by the end of the decade, the expectation of car ownership had increased, with consequent changes to the choices available for getting around the city. Edinburgh's tram system was the most affected by these changes.

> I loved the Edinburgh trams, the yellow slatted wooden seats, the whine and rattle as they gathered speed, the driver's low-pitched bell to shoo people out of the way.
>
> Ludovic Kennedy, from his autobiography *On My Way to the Club*, 1990

Trams in Edinburgh have a long history. In 1871, the Edinburgh Tramways Act established the Edinburgh Street Tramways Company with the authority to construct tramway routes in Edinburgh, Leith and Portobello 'to be worked by animal power only'. Edinburgh's 142-year affiliation with trams began in November 1871, when the company introduced a 3½-mile horse-drawn line from Haymarket, via Princes Street and Leith Walk, to Bernard Street, Leith. This replaced an earlier coach service that

had run along the same route – the only difference being the presence of guide rails that provided passengers with a noticeably smoother journey.

Over the next decade, the popular tram network began to develop into new districts such as Newington and Portobello, with further expansion significantly hindered by the notorious hilly ground in certain areas of the city – as many as five horses were required to tackle the formidable slopes of the New Town. In January 1888, this problem was solved by the introduction of a cable-hauled system, a method that was already in use in San Francisco – a city renowned for its steep gradients, much like Edinburgh. The cables ran in a channel in the middle of the track and were steam-driven from four power stations. The tramcar employed a gripping mechanism, which dropped into the channel and connected the vehicle to the running cable, hauling it along at a leisurely 12 mph. The new technology enabled the tramcar to appear in areas of the city that had hitherto proved too difficult for horses to negotiate. It was also around this time that the Shrubhill Works in Leith began to produce its own unique models of tramcar.

In 1905, when the newly created Leith Corporation Tramways pioneered the use of electric traction, an anomaly appeared that would take nearly twenty years and the unification of two separate autonomous burghs to sort out. Since Edinburgh's system was predominantly cable-run and Leith's electrified, passengers travelling either way along Leith Walk were forced to change vehicles at the Pilrig city boundary. The hugely unpopular merger between the two burghs in 1920 (the result of a referendum in which Leith residents voted five to one in opposition) formed the catalyst for the upgrade of the Edinburgh network to an electric system. Electric trams finally crossed the frontier on 20 June 1922 and the chaotic interchange known as 'the Pilrig muddle' was eradicated. Edinburgh's last cable tram operated a year later on the Portobello line. Today, a short section of original tram rail and cable track remains in situ at Waterloo Place, the sole surviving relic of the old system in central Edinburgh.

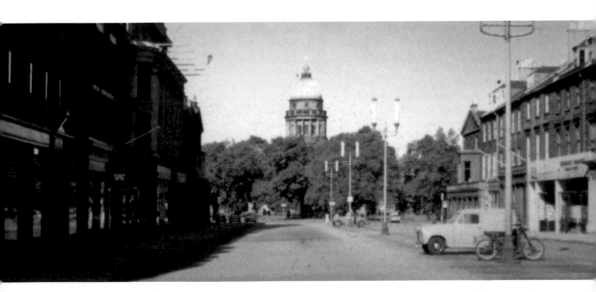

No shortage of parking spaces and no parking meters on George Street in 1958. (*Photograph courtesy of George Angus*)

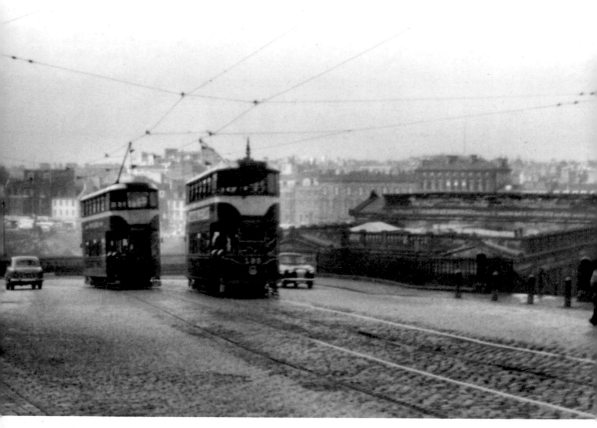

The last trams on the Mound. (*Photograph courtesy of of Thomas Morgan McGurk*)

There were various service restrictions to the tram service during the Second World War and, in 1941, with many men serving in the Armed Forces, conductresses were employed for the first time. From the end of the war, in 1945, all services started to rapidly get back to what was to be a relatively short term normality – and in the twelve-month period ending in May 1947, a record number (192,892,899) of journeys were made by tram.

In the years following the end of the Second World War, all municipal tramways in the UK (with the sole exception of Blackpool) were progressively closed and replaced by buses. Post-war urban expansion required a more cost-effective transport solution. This arrived in the shape of the motor bus, which could offer limitless flexibility compared with the restricted rail-bound trams. The gradual closure of tramways across the country over the next decade signalled a shift in preferences for transportation.

Edinburgh Corporation initially took advantage of this situation by adding eleven former Manchester cars to the fleet between 1947 and 1949. However, in March 1950, tram service No. 18 (Waverley–Liberton Dams) was withdrawn and replaced by buses, although no rails were lifted. In June 1950, proposals to remove a quarter of the tram system were considered and, although initially rejected by Council committees, they were finally approved later in the year. Service No. 24 (Waverley–Comely Bank) was the next to be replaced by buses in June 1952.

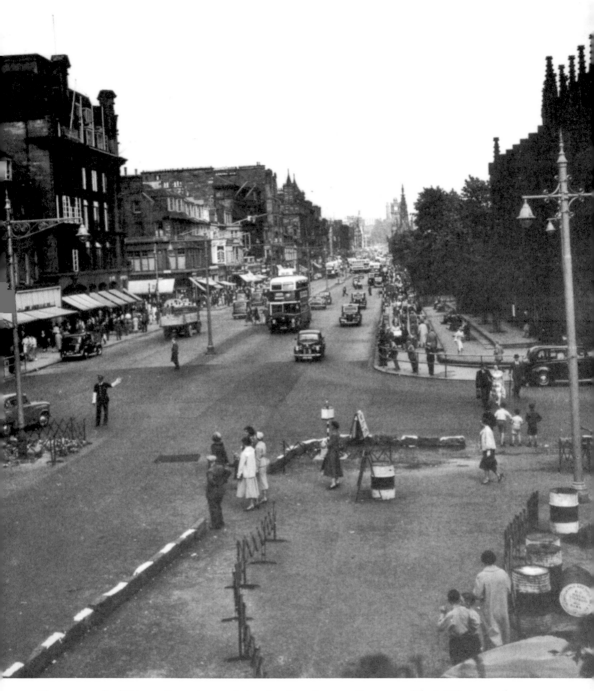

The west end of Princes Street in 1956 shortly after the tram lines were lifted. (*Photograph courtesy of Seonaidh Guthrie & LMA*)

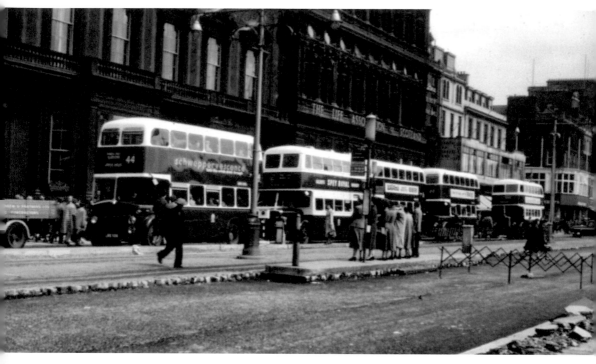

Lifting the tram lines on Princes Street. (*Photograph courtesy of Thomas Morgan McGurk*)

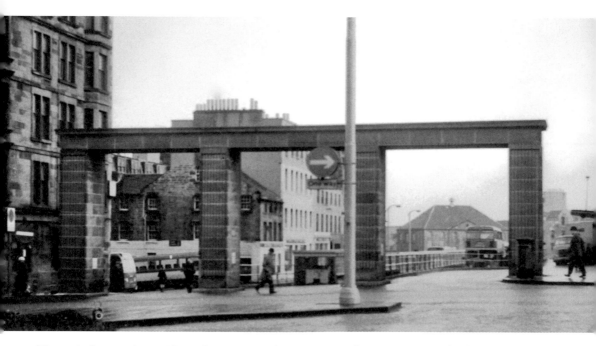

The main bus station, with its distinctive archway to St Andrew Square, was built following a fire in 1952, which destroyed a former cinema on the site. The Harvey Nichols department store now occupies the site.

There were significant public protests about the closure. However, in September 1952, the Council finally approved the closure of the whole tram system. This progressed rapidly over the course of the following years and, at the start of 1956, only ten of the original twenty-eight routes were still operational. The tram rails were removed on the closure of routes, which involved considerable disturbance and road works. The granite setts that carried the rails were generally replaced by tarmac.

The final day of the trams fell on 16 November 1956. That evening, a grand procession of tramcars paraded from the Braids terminus to Shrubhill depot in Leith, taking in much of the original 1871 route. Ten trams were laid on due to the demand for tickets – one car containing the city councillors who had consigned the trams to the history books in the first place. At the Mound, an enormous crowd gathered to bid an emotional farewell to a much cherished thread of the city's colourful fabric. The final part of this last journey was along Princes Street, York Place and Leith Walk to the Shrubhill Depot, bringing eighty-five years of tram operations in Edinburgh to a close. It also seems that many of the fittings had been removed by tram fans with screwdrivers on the way.

It represented the passing of an era and was an emotional night for the many with fond memories of the trams and those who believed that they were an effective method of public transport. From the hundreds of cars that graced the city over the years, only tramcar No. 35, built at Shrubhill in 1948, has survived. It is located at Crich Tramway Museum in Derbyshire.

Edinburgh was the second of the four large Scottish city tram systems to be abandoned. Dundee was the first, a few weeks before Edinburgh. Aberdeen's trams followed in May 1958 and Glasgow's in September 1962.

The inflexibility of the tram routes, where a single accident could seize up the whole system, was given as the main reason for the move to buses. However, many considered that the abandonment of an efficient electric public transport system was taken without due consideration for the future. It must also have seemed inappropriate, in 1956, right in the middle of tensions over President Nasser of Egypt's proposal to nationalise the Suez Canal and potential fuel shortages, which would inevitably affect bus operation.

It seems that anyone old enough to have known the Edinburgh trams remembers them with enormous fondness, tinged with sadness for their demise.

Edinburgh Corporation had introduced its first bus in 1914 and in 1928. Given the increasing importance of buses, the Edinburgh Corporation Tramways Department was renamed the Edinburgh Corporation Transport Department. Trams had still outnumbered buses until as late as 1952, but after the decision to concentrate public transport on buses, Edinburgh Corporation Transport ordered 370 new and 77 refurbished vehicles in the 1953–57 period. These were mainly double-decker Leyland Titans, which served the city for around twenty years.

The steep slope of the Mound was difficult for buses to manoeuvre in icy conditions, and in 1959 an electric blanket was laid under the road to prevent ice forming. The project was not a great success and it was unplugged a few years later. The Beeching Report and the move towards greater car use by the end of the decade also resulted in the loss of a number of rail services.

The grand North British Railway's Leith Central station was the first fatality of the decade – closing in 1952. In its later derelict condition, it was much used by drug addicts and the inspiration for the ironic title of Irvine Welsh's book *Trainspotting*.

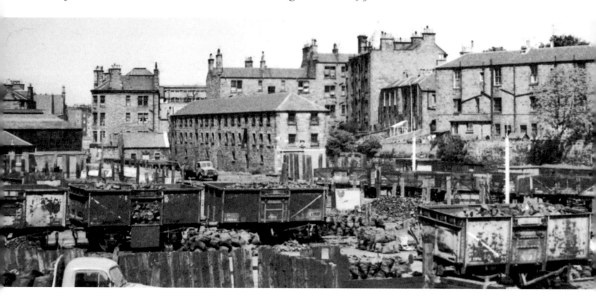

St Leonards rail station served the first rail service between Edinburgh and Dalkeith. The line was built in 1831 and was known as the Innocent Railway, possibly due to the slow rate of travel – it was originally horse-drawn. This image was taken when the site was used as a coal yard in the 1950s. It has since been developed for housing. The original engine shed remains as the Engine Shed café.

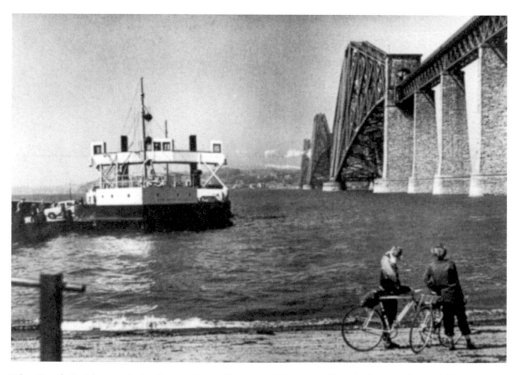

The Forth Bridge and the ferry, *Mary Queen of Scots*, at South Queensferry. (*Photograph courtesy of Grace Melrose & LMA*)

The Edinburgh South Suburban Railway – the SouthSub – opened in 1884 for freight and passenger services and, with stations at Gorgie, Craiglockhart, Morningside, Blackford, Newington and Duddingston, contributed to the southern expansion of the city. It was a popular and convenient way of getting around Edinburgh in the 1950s. However, the greater flexibility of buses and increasing car use started to make it unprofitable and passenger services were withdrawn in September 1962, although it remains an important freight route.

Princes Street railway station, also known as the 'Caley', stood at the west end of Edinburgh between 1870 to 1965. It was the largest train station in Scotland, occupying a vast stretch of the city centre from the north-eastern tip of Rutland Street all the way to where present-day Festival Square meets the Filmhouse cinema on Lothian Road.

The western-based Caledonian Railway Company first extended a line into Edinburgh in 1848, which saw the erection of a temporary wooden station on Lothian Road. The initial Lothian Road station existed until 1870, when the line was extended a little further north towards Princes Street, the shift in location forcing a name change. By the 1890s, with passenger levels rapidly increasing, the decision was taken by the Caledonian Railway Company to create a grand terminal for Edinburgh – one to rival Edinburgh Waverley. Boasting seven platforms, street level access and a colossal 850-foot-long bayed roof, it was a formidable rival to Edinburgh's other station.

As the turn of the nineteenth century approached, an influx of tourism, particularly among the upper classes, provoked many rail companies to cash in by providing convenient onsite accommodation for their passengers. In 1902, the North British Railway Company built the luxurious North British Hotel at the east end of Princes Street. Its proposed construction in 1895 would have undoubtedly spurred those running the Caledonian line into action and, on 21 December 1903, The Caledonian Hotel officially opened. The hotel was clearly designed to be the focal point of the entire complex, having been built directly above the pre-existing station that faced Princes Street. A new entrance from Rutland Street, featuring ornate iron gates that are still there today, provided the station with adequate vehicle access.

Up until the end of the Second World War, Princes Street station thrived. It became the preferred arrival destination for the British monarchy on state visits to the city. Its ease of access to Princes Street was deemed an absolute necessity for the purpose of processions, with the alternative prospect of tackling the steep inclines of Edinburgh Waverley seen as significantly less favourable. However, in 1948, with the advent of nationalisation across Britain's numerous railway networks, Princes Street station, despite its size, opulent interior and regal approval, was deemed surplus to requirements. Over the next seventeen years, service was reduced gradually station by station, sleeper by sleeper, until September 1965 when the grand Princes Street terminal finally met the end of the line.

Few remnants of Princes Street station have survived since the 1960s, though fragments are still evident. The newly refurbished Caledonian Hotel, no longer under railway ownership, is an obvious example, with the aforementioned cast-iron gates on Rutland Street now providing an elaborately-styled hotel car park entrance. Also within the hotel, since its £24-million conversion into a Waldorf Astoria, resides the old station clock – restored, yet still set five minutes fast to ensure passengers made their trains on time. The West Approach Road, completed during the 1980s, runs along much of the former track bed of the main line, and travellers passing underneath the iron bridges

spanning Morrison Street, Gardner's Crescent and Grove Street are provided further evidence of the road's previous incarnation. The once heavily active Lothian Road parcels office, situated between the hotel and the West Approach Road, endured until the early 1990s, later becoming the site of Standard Life. The remainder of the large gap site left in the station's wake has also seen dramatic redevelopment over the past twenty-five years, its sheer scale enabling Edinburgh to create a bustling financial district within the city centre. Princes Street station certainly deserves more than a footnote in the annals of Edinburgh's rich civic history, but the fact that its demise has ultimately led to genuine economic prosperity for the capital has softened the impact of its loss.

The only way to cross the Forth in the 1950s was by train or ferry. However, once the 'Car had become King', the car ferry crossing of the Firth of Forth at Queensferry was inadequate to cope with the increased demand. There had been a ferry at Queensferry since the eleventh century, when Queen Margaret established a service to transport religious pilgrims from Edinburgh to Dunfermline Abbey and St Andrews. In the 1920s and 1930s, the only vehicle crossing was a single passenger and vehicle ferry but, by 1958, due to increasing demand, there were four ferry boats operating 40,000 crossings annually, carrying 1.5 million passengers and 800,000 vehicles.

In 1947, the UK Government approved an Act of Parliament to oversee the implementation of a bridge to replace the ferry service. In 1955, an alternative scheme for a tunnel beneath the waters of the Forth was proposed, but was soon abandoned.

The final construction plan for a road bridge was accepted in February 1958 and work began in September of that year. It was opened by Queen Elizabeth II and the Duke of Edinburgh on 4 September 1964, and the ferry service was discontinued from that date. When it was completed, the bridge was the longest suspension bridge outside the USA and the fourth longest in the world, with a total span of 2,828 metres.

The new airport terminal at Turnhouse was opened in April 1956. It cost £84,000 and was designed to cope with an annual transit of 75,000 passengers. There had been an 'aerodrome' at Turnhouse since 1915, which was used by the Royal Flying Corps and later by the RAF. In the days before the Second World War, air circuses demonstrating mock dogfights and aeronautics were a major attraction.

Flying was dangerous but glamorous in the 1950s. The main airline operator at Turnhouse in the 1950s was British European Airways. In 1952, a flight from Edinburgh to London in a 'Viking' plane cost £8 return. In April 1955, they introduced first-class flights to and from London by 'Viscount' (701 series) aircraft – the flight was called 'The Festival'. 'Viscount' 802 and 806 series aircraft appeared next on the Edinburgh–London route, and 'Pionair' aircraft were used on the services to Glasgow, Aberdeen and the North. An Edinburgh to Dublin service was opened in 1952 by Aer Lingus.

More unusually, there was a short-lived flying boat service between Southampton and Leith.

Planes at the time were much more sensitive to take-off weight and on the way to the plane passengers had to pass a large, red weighing machine manned by an official, who would scrutinise each passenger and publicly weigh anyone that looked overweight.

3

LIFE IN
LEITH

Leith was Scotland's main port for many centuries, trading across the North Sea and south to France. In the 1950s, Leith was still a bustling port, supporting a deep-sea fishing fleet and shipyards. The streets were full of shipping agents and ship chandlers.

Leith was first set on record in the twelfth century, followed by a more notable update in 1329, when Robert the Bruce passed over control of the shoreline hamlet to the citizens of Edinburgh. In the early days, it consisted of the two independent settlements of South Leith and North Leith. The 1500s saw the emergence of a joint identity.

Over the centuries, Leith has witnessed and influenced the historic affairs of Scotland's capital, only 1½ miles distant. Despite the grandeur of its dominant neighbour, the port has played a great part in the prosperity and wealth of Edinburgh. Industrial growth, as well as population increase, led to the expansion up Leith Walk of the living and industrial quarters. At the same time, Edinburgh was also expanding and spilling down to the sea. The two came into physical contact at the Pilrig boundary on Leith Walk. In 1920, despite a plebiscite in which the people of Leith voted 29,891 to 5,357 against the merger, Leith was merged with Edinburgh.

By the time of the reluctant amalgamation, Leith contained its successful port, significant industrial enterprises, shipbuilding, warehouses, bonds and a population densely packed into ageing tenements and housing stock.

Shipbuilders Henry Robb Ltd, known colloquially as Robb's, was established in Leith in 1918. Their Victoria Yard was situated at the West Pier in Leith Docks. The business was always limited in scale due to the shallow waters of the Forth, and Robb's was notable for building small-to-medium sized vessels, tugs, dredgers, cargo vessels and passenger cargo vessels.

Throughout the 1950s Robb's provided long-term jobs and apprenticeships in every trade relating to shipbuilding. The workforce numbered in excess of 500 in the 1950s, adapting from its war work to produce cargo ships and utility vessels. Life in Leith's shipyard after the war was still demanding. A basic wage of 22/- per week was standard for a qualified machine shop worker. Sick pay was non-existent, with workers having to rely on their workmates to have a whip round if they were off work. Christmas Day was a normal working day. In 1955, the company moved from private to public hands. Robb's yard closed in 1983 and the land it once occupied was redeveloped as the Ocean Terminal shopping centre, home to the Royal Yacht *Britannia*.

Leith has a long association with whisky. In the 1950s, the scores of bonded warehouses in Leith matured 90 per cent of all the whisky made in Scotland, and Vat 69 was distilled locally by Sandersons. Crabbies Green Ginger Wine, that essential addition to whisky to create a Whisky Mac, was also produced in Leith.

Whaling was a mainstay of Leith for centuries. Originally focusing on local waters, by the nineteenth century the whaling ships were travelling to the Antarctic. The Christian Salvesen Company was the main operator, and their whaling stations in the South Atlantic led to the main settlement of South Georgia in the Falklands being named Leith.

Leith is also the home Rose's lime juice. The juice, originally intended for use by sailors to prevent scurvy, was patented by Lauchlan Rose in 1867. Rose's first lime juice factory was set up on Commercial Street in Leith in 1868. In 1957, Schweppes acquired the company and it operated in Leith until 1982.

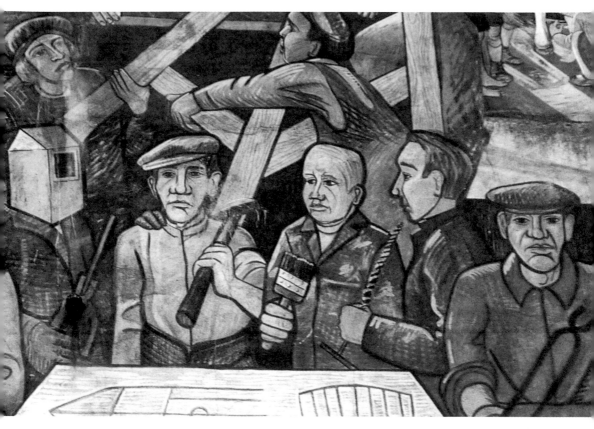

Above: Workers at Henry Robb's, depicted on the Leith Mural at North Junction Street.

Right: The Leith Flour Mills (locally known as Tod's Mills) in Commercial Street were the largest in Leith. The original mills were burned down in 1874. Leithers still remember and speak of this fire as one of the most destructive in the history of the town.

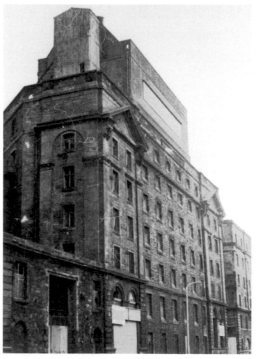

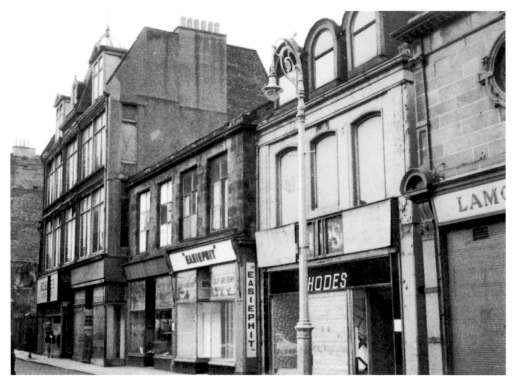

Shops in Leith's old Kirkgate.

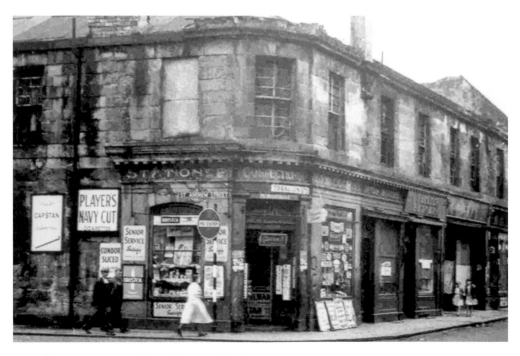

St Andrews Street in Leith was lost to redevelopment.

The 1950s saw the final days of what older Leithers would describe as the heart of Leith. The redevelopment of the 1960s would see to this. Most of the crammed tenements, shops and small workshops of the 1950s were sited along the old and ancient thoroughfares in the heart of Leith. The Kirkgate, St Andrew Street, Tollbooth Wynd, Bridge Street and many more would disappear in the coming decade.

In the 1950s, the buildings may have been crumbling but Leith didn't lack 'colour' or a community identity. Interestingly, the citizens of 1950s Leith knew that modernisation had to arrive but what they couldn't understand was why it didn't arrive in the same form as the Old Town regeneration. The city fathers were clear that, by 1920, when Edinburgh took over the port, the building stock had already deteriorated significantly and was in need of attention even then. Delay through the 1930s depression, followed by the interruption of the war, followed by the austerity of the 1950s, finally saw the 'modernisation' of Leith in the 1960s. Many reasons have been put forward for the lack of progress, such as difficulties tracing owners of properties and rehousing a population wedged together in densely populated pockets of Leith. All this meant that improvement was slow, but when progress came in the 1960s, the face of Leith and the lives of Leithers changed forever.

1950s Leith boasted excellent cinemas, such as The Palace, The State, The Capitol and The Alhambra, which closed in 1958. The Eldorado offered Leithers a venue for dance and romance if they wished a local liaison. As in any port the public houses were notorious, particularly on the Shore. When a ship was in the crew would make their way round the various watering holes of Leith often seeking female companionship. Of course, in the 1950s a regular fleet of trams and buses transported maritime visitors up the Walk to dance halls such as Fairley's on Leith Street.

The Leith of the 1950s had a thriving population made up of old and the young, families with roots going back generations. In the late 1960s, Leith was populated by more middle-aged and elderly residents. Evidence of this could be seen in the streams of buses crammed full of younger workers heading to the newly built edges of Edinburgh at the end of their working day in Leith.

Rubble from the demolition of the centre of Leith was dumped on the shoreline as part of land reclamation work. The significance and symbolism of this was not lost on many old Leithers at that time, but the sacrifice was accepted in the hope of a new Leith to come.

After decades of industrial decline, slum clearance and resultant depopulation in the post-war era, Leith gradually began to enjoy an upturn in fortunes in the late 1980s. It has undergone significant regeneration and is now a busy port with visits from cruise liners, the base for the Royal Yacht *Britannia*, as well as the home of Scotland's civil service at Victoria Quay.

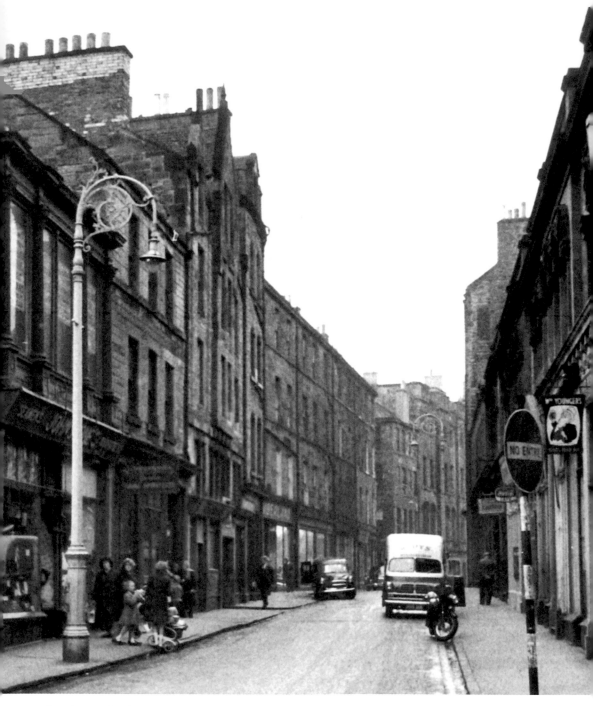

Tolbooth Wynd, taken from the bottom of the Kirkgate looking towards the Shore. All this disappeared with the redevelopment of the Kirkgate in the 1960s. The slum clearances of the 1930s, bomb damage and the post-war housing programmes had emptied many of the streets in Leith. However, vestiges of the effervescent character of the area remained in the 1950s. The old Kirkgate, Leith's high street, was a bustling community of shops and houses, which was lost to redevelopment in the late 1950s.

4
FESTIVALS

presents

The
Edinburgh
Tattoo
1950

at the Castle

Produced by LIEUT.-COLONEL G. I. MALCOLM OF POLTALLOCH

PROGRAMME
Price 1/-

Every August, Edinburgh welcomes performers and visitors of all nationalities for a three-week festival – the greatest arts event in the world, when Edinburgh plays host to the best in music, opera and drama.

The Edinburgh International Festival of Music and Drama had its birth in 1947 and was in its infancy in the 1950s. In the dark and austere times following the end of the Second World War, the intention was to lead people towards a new way of life through the common enjoyment of the best in music, drama, and art.

Rudolf Bing, manager of the Glyndebourne Opera House, first conceived the ambitious idea of a festival to revitalise cultural activities. Bing visited a number of places, hoping to establish a home for his arts festival, but received little encouragement. Edinburgh was much more responsive and fortunate that Sir John Falconer, the Lord Provost at the time, recognised the value that the festival would bring to Edinburgh, and he promoted the advantages of Edinburgh as a home for the event.

The first festival was fairly modest, but a major act of faith in the austerity of post-war Britain. It opened on Sunday 24 August, 1947 and in its first year was visited by HM the Queen (Queen Elizabeth the Queen Mother) and by Princess Margaret. Glyndebourne Opera presented *The Marriage of Figaro* and *Macbeth*, the Vienna State Orchestra played, the Saddlers Wells Ballet danced, Kathleen Ferrier sang and Alec Guinness appeared in *Richard II*.

The festival was the first major post-war festival of the arts in Europe and in the 1950s was attracting 90,000 visitors to Edinburgh. Some of the world's finest artists and companies were invited to perform at the city's theatres during the decade.

Rudolf Bing's worldwide connections were invaluable in attracting performers and there were a number of outstanding festival highlights during the 1950s: in 1950, Sir Thomas Beecham's conducting of Handel's *Music for the Royal Fireworks* on the Castle Esplanade, and Sir John Barbirolli and Leonard Bernstein's appearances; in 1951, there was a stunning performance of Verdi's *Requiem* by the New York Philharmonic Orchestra, conducted by Victor de Sabata with a chorus by La Scala; in 1952, the Saddlers Wells Ballet performance of Stravinsk's *The Rake's Progress*; and in 1954, the exhibition titled 'Homage to Diaghilev'.

During the 1950s, the Assembly Rooms on George Street was the venue for the Festival Club and the pipes and drums of the Edinburgh City Police marched every morning along Princes Street. There were nightly concerts in the Usher Hall, opera in the King's Theatre and morning concerts in the Freemason's Hall by soloists or chamber-music groups. Drama was presented at the Royal Lyceum Theatre with three plays, each running for one week; plays were presented on the open stage at the Assembly Hall of the Church of Scotland; at the Gateway Theatre and the Church Hill Theatre. In the Royal Scottish Academy there were major exhibitions of the works of Rembrandt, Degas, Renoir, Gauguin, Cezanne and Braque.

In its first year, the festival attracted eight theatre groups that were not part of the official festival. These groups aimed to take advantage of the large crowds to perform their own alternative theatre. The Fringe got its name in 1948 after one commentator wrote, 'Round the fringe of official Festival drama, there seems to be more private enterprise than before.'

The Fringe did not have any official organisation until 1951, when students set up a drop-in centre in the YMCA, where cheap food and accommodation were available to

participating groups. In 1959, the Festival Fringe Society was formed and a constitution was drawn up, in which the policy of not vetting or censoring shows was established. Nineteen companies participated in the Fringe in that year.

In 1952, the first late-night revue, *After the Show*, was staged. In 1960, this was upstaged by the enormously successful and influential comedy revue *Beyond the Fringe*, which brought together Peter Cook, Dudley Moore, Alan Bennett and Jonathon Miller. Their four performances at the Lyceum Theatre established the Fringe's reputation for the quality of its shows. When the revue transferred to London it became a sensation and, in 1962, the show moved to New York with its original cast. *Beyond the Fringe* introduced a new form of unorthodox comedy and was the forerunner of many British television programmes, including *That Was the Week That Was* and *Monty Python's Flying Circus*.

The first Edinburgh Festival featured a closing ceremony on the Castle Esplanade. This was a forerunner of the military tattoo, which was first held in 1950 with a nightly audience of 7,000 enjoying the military spectacle against the striking backdrop of Edinburgh Castle.

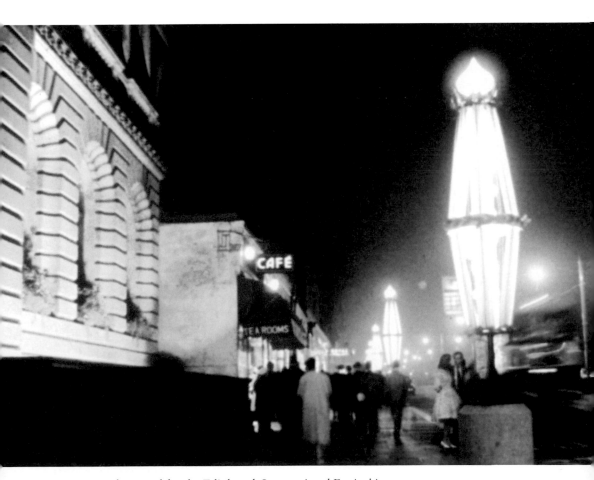

Princes Street decorated for the Edinburgh International Festival in 1959.

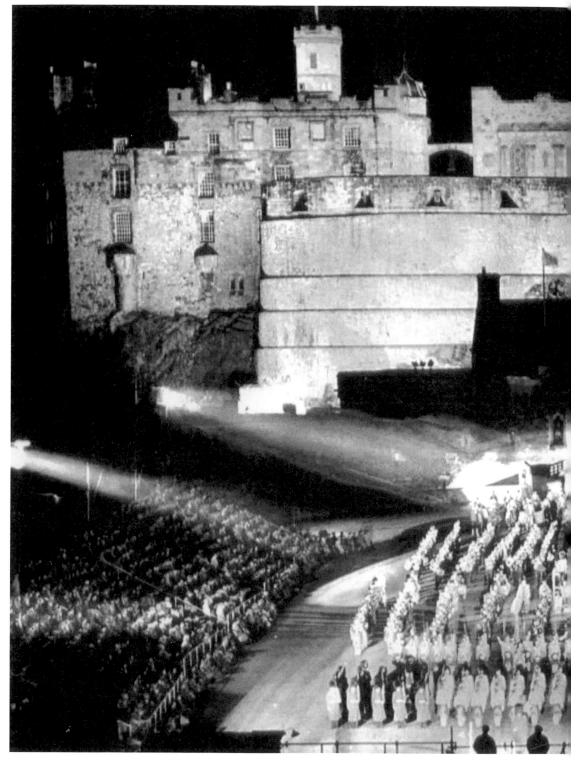

The Grand Finale of the Tattoo in 1950. (*Photograph courtesy of Edinburgh Military Tattoo*)

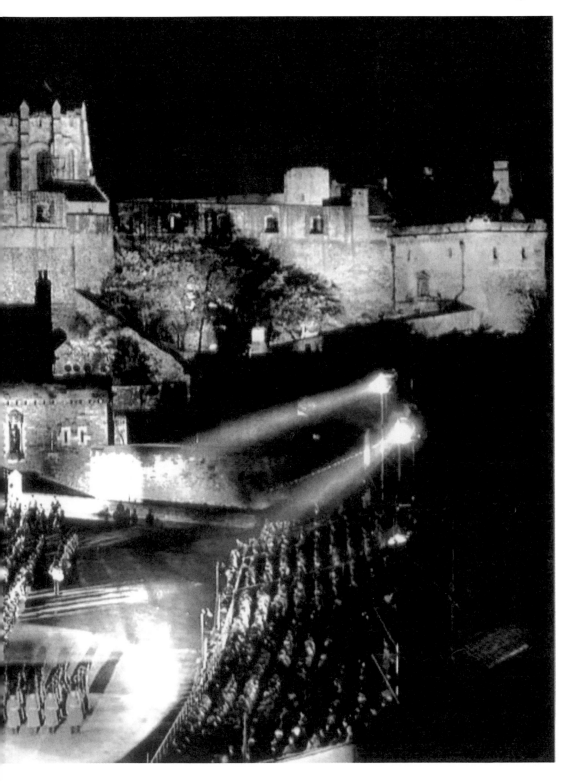

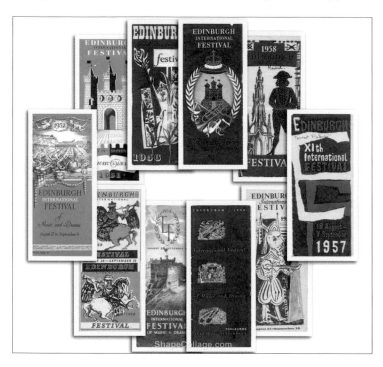

The Edinburgh Festival programme covers from the 1950s. (*Photograph courtesy of Edinburgh International Festival*)

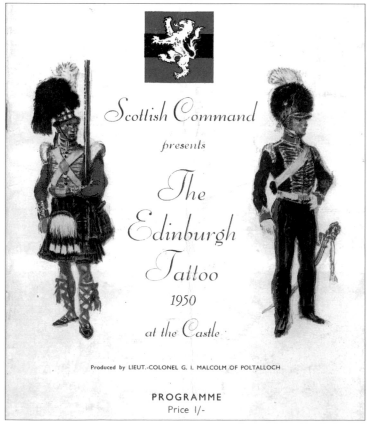

The front cover of the programme for the first ever Military Tattoo in 1950. (*Photograph courtesy of Edinburgh Military Tattoo*)

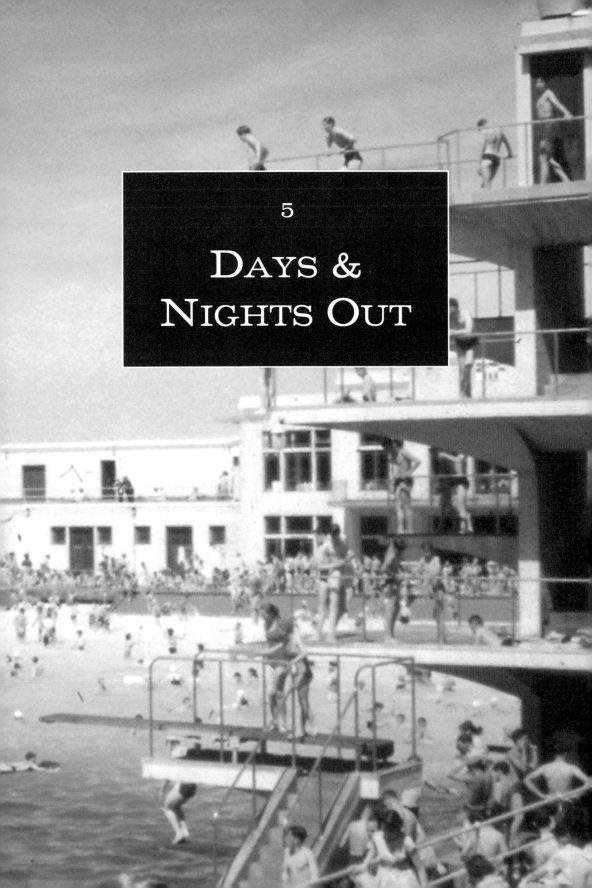

5

Days &
Nights Out

The national celebration of the Coronation on 2 June 1953 was the biggest party of all in the 1950s. Whole communities got together to celebrate the crowning of the new monarch, and it would have been a big day out for many in Edinburgh. As late as 1949, two out of three people in the country had never seen a television. The broadcast of the Coronation was the incentive for many people to stretch their budget to have one installed. Still, only 3 million British households had a television at the time (a figure that had trebled by the end of the decade) and neighbours packed the houses of the lucky few who owned or rented a set to watch the event – the first time that a monarch's coronation had been televised.

Televisions at the time were housed in large, wooden cabinets and the screens were no more than 9 inches wide, although many people invested in a thick magnifying glass that sat in front of the screen for the Coronation. This assumed that a reasonable signal was available, which often required someone to walk around the room with the aerial, and there was no choice about which channel to watch – it was BBC or nothing. An estimated 20 million people watched the Coronation in foggy black-and-white and the event took the television a step nearer becoming the centrepiece of the home.

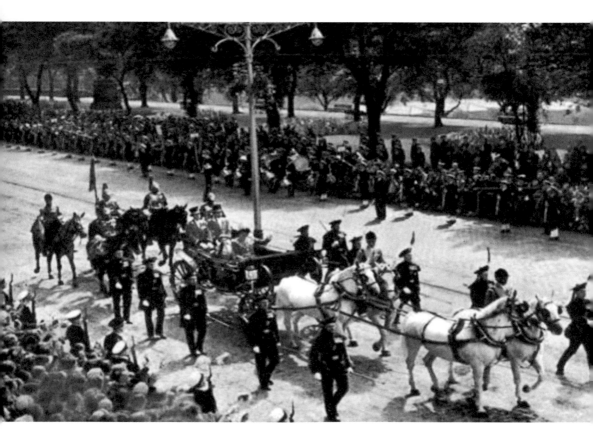

The procession of HM the Queen and HRH the Duke of Edinburgh in June 1953 on their Coronation state visit to Edinburgh. Huge crowds lined Princes Street to catch a glimpse of the new monarch. The sixteen coach horses were all serving St Cuthbert's milk delivery horses. (*Photograph courtesy of Scotmid*)

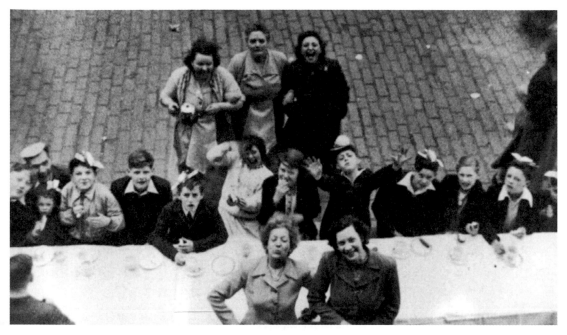

Celebrating Coronation Day on Newton Street, Gorgie. (*Photograph courtesy of Andrew Vardy & LMA*)

Street parties followed the television viewing of the Coronation, with tables and chairs laid end to end on streets decked out in bunting. This is a group celebrating on Dumbiedykes Road. (*Photograph courtesy of Jean Bell & LMA*)

The 1951 Festival of Britain was a nationwide programme of events to celebrate Britain's contribution to science, technology, architecture and the arts. It was intended to provide an optimistic and progressive view of Britain's future in the aftermath of the Second World War. The centrepiece of the festival was the exhibition around the South Bank of the Thames in London. It is generally considered to mark when the 1950s really started and the post-war recovery got underway.

Edinburgh's contribution was the Gathering of the Clans, the highlight of which was to be the March of Thousand a Pipers along Princes Street on 18 August 1951. The event took place the day before the opening of the International Festival and preceded the Gathering of the Clans and Highland Games at Murrayfield. The pipers were scheduled to march down the Mound and turn west into Princes Street, marching sixteen abreast. However, the police were unable to control the vast crowd, estimated at half a million, that turned up to watch the parade and the pipers had to fight their way through the mêlée in twos and threes. The *Scotsman* later summed it up with the headline 'CHAOS IN PRINCES STREET'.

In the 1950s, Princes Street and the gardens provided a range of possibilities for a day out. In an active mood, there was an 18-hole putting green and bowling green in East Princes Street Gardens. The Ross Bandstand in Princes Street Gardens was popular for open-air concerts and dancing, and crowds also gathered to hear the rhetoric at Speakers' Corner beside the Royal Scottish Academy.

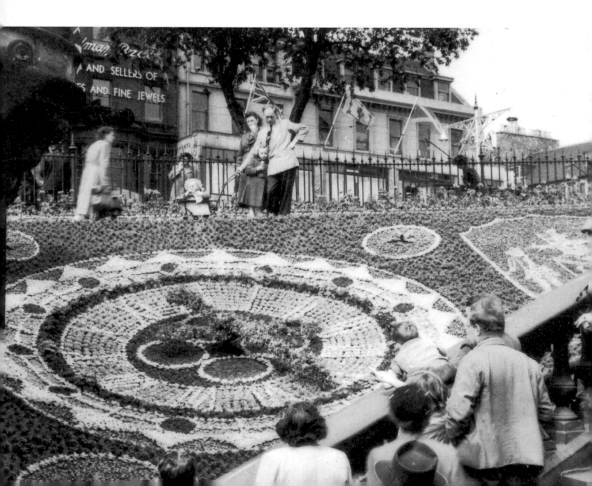

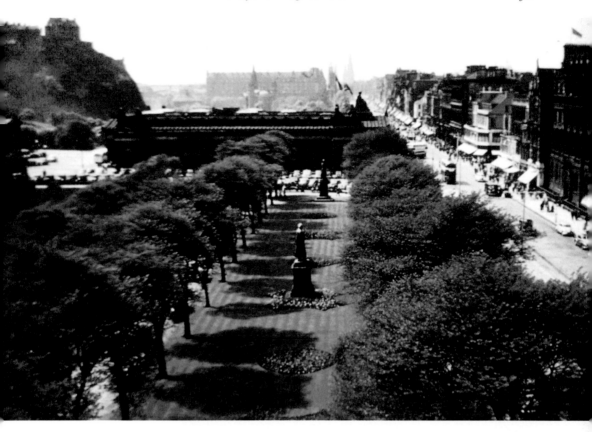

Above: East Princes Street Gardens.

Right: Princes Street decorated for the Coronation state visit of the Queen in 1953.

Opposite: Admiring onlookers at Edinburgh's floral clock in West Princes Street Gardens in 1955. Edinburgh's floral clock was first planted in 1903 and was the first in the world.

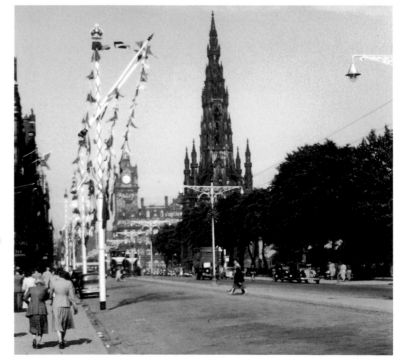

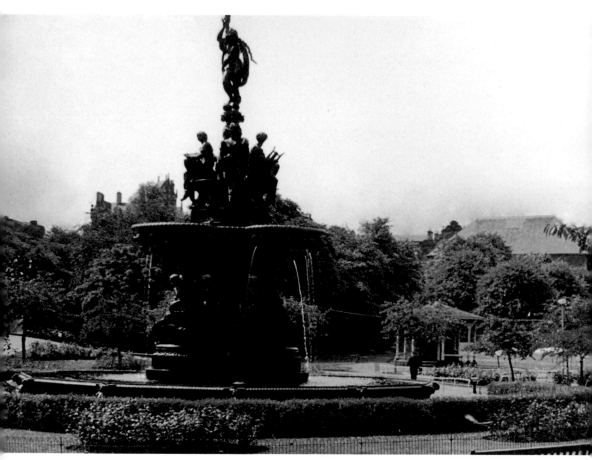

The Ross Fountain, West Princes Street Gardens. The fountain was gifted to Edinburgh by local gun-maker and philanthropist, Daniel Ross, after it was displayed at an International Exhibition held in London in 1862. However, there were lengthy wrangles concerning the fountain's location – and even construction. The French design of the fountain incorporated an abundance of voluptuous nude female figures, which shocked the more prudish elements of Edinburgh society at the time. One of the most vehemently opposed was Dean Ramsay of nearby St John's church, who labelled the nudity-laden structure, 'grossly indecent and disgusting; insulting and offensive to the moral feelings of the community and disgraceful to the city'. The Ross Fountain was finally unveiled in 1872.

The Zoological Society of Scotland was established at a meeting in Edinburgh City Chambers on 18 March 1909. It was incorporated by Royal Charter in 1913 and in the same year the site at Corstorphine Hill House was acquired. The zoo was granted the prefix 'Royal' by King George VI in 1948 and, in 1958, the Queen granted a further charter defining the aims of the Society.

The first of the famous collection of penguins arrived in 1913, when four king penguins, a gentoo and a macaroni were presented to the zoo by the Leith whaling firm Christian Salvesen & Co. after a 7,000-mile journey from South Georgia. Five years later, the first ever king penguin chick bred north of the equator was born.

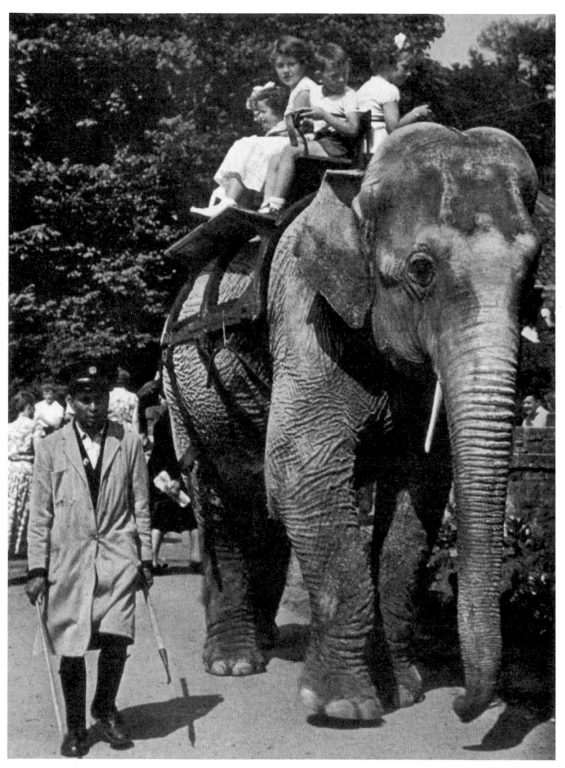

Elephant rides at the zoo.

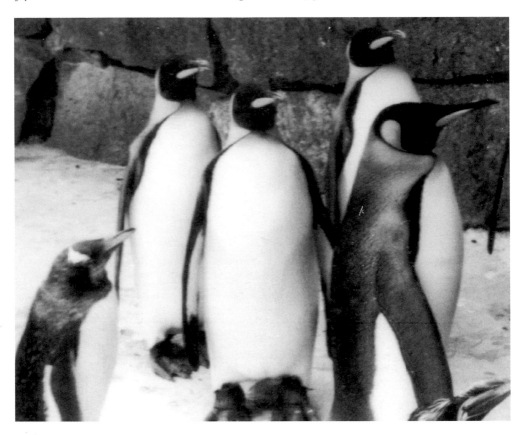

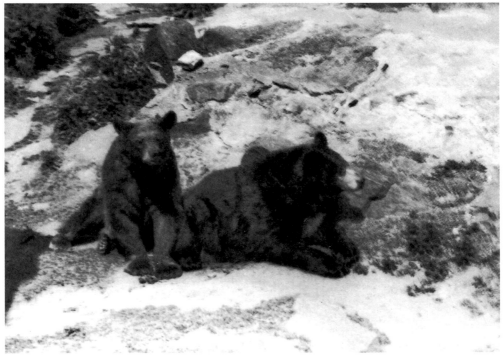

The Penguin Parade and Chimpanzee's Tea Party were well-established attractions during the 1950s. The first Penguin Parade started in 1951 and has remained a highlight of a visit to Edinburgh Zoo ever since. The Children's Farm, which opened in March 1958, included a complete farmhouse, steading with everything reduced to the scale of Shetland ponies representing Clydesdale-cart horses and stocked with young or miniature animals.

One of the more famous residents of the zoo during the 1950s was Wojtek, the Soldier Bear. In 1942, Wojtek was adopted as a young cub by soldiers serving in a unit of the Polish Army in Iran during the Second World War. Reared by the soldiers, he was fed fruit, marmalade, honey and syrup, and was often rewarded with beer, which became his drink of choice. He also learned the habit of smoking cigarettes. Wojtek would have play wrestles with the soldiers and was taught to salute.

The bear became the mascot of the unit and, to get him on a transport ship when the troops were moved to Italy, he was officially drafted into the Polish Army as a corporal. During the Battle of Monte Cassino, Wojtek helped by transporting ammunition and in recognition of his heroism and popularity, an effigy of a bear holding an artillery shell became the official emblem of the unit.

In 1945, Wojtek was moved to Scotland along with his army unit and became popular with local civilians and a bit of a media celebrity. Following demobilisation in 1947, Wojtek was given to the Edinburgh Zoo, where he spent the rest of his days. He was often visited by former Polish soldiers who would toss him cigarettes, which he then proceeded to eat because there was no one there to light them for him! Wojtek died in 1963, at the age of twenty-two.

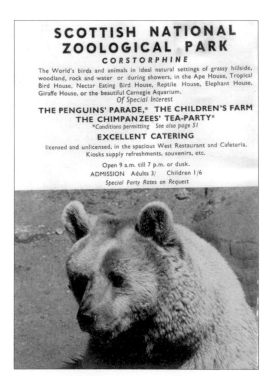

Right: Advert for the zoo from the 1950s featuring Wojtek the Soldier Bear.

Opposite above: A group of Edinburgh Zoo's famous collection of penguins in 1955.

Opposite below: Wojtek the Soldier Bear and Friend at Edinburgh Zoo in 1955.

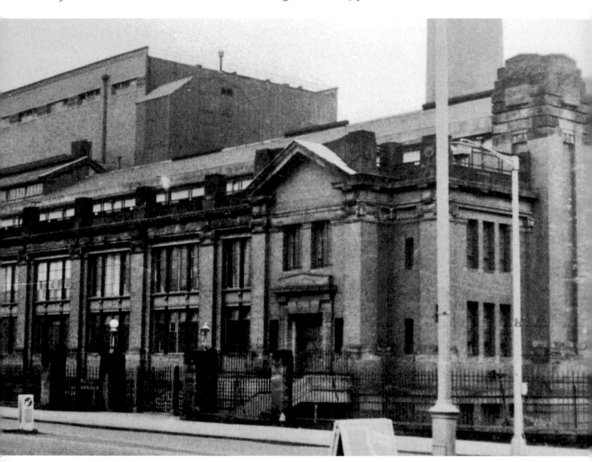

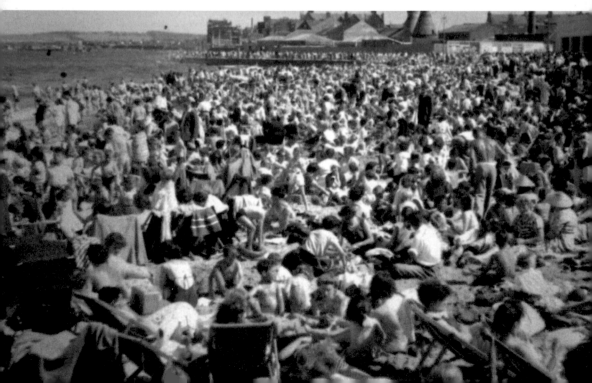

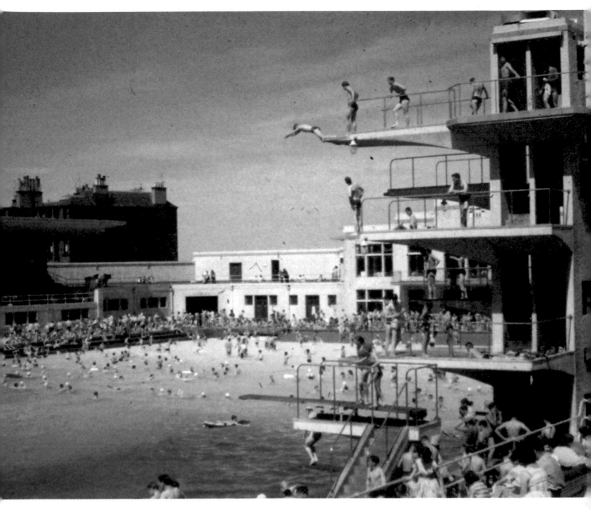

Above: The lofty diving boards at Portobello Bathing Pool were a big summer attraction in the 1950s. (*Photograph courtesy of Danny Callaghan*)

Opposite above: Portobello Power Station was the source of heat for the water in Portobello Pool. The Station provided the city of Edinburgh with electricity for over half a century. It was built by Edinburgh Corporation in 1923 and King George V was present at the prestigious opening ceremony. The new power station was one of the most efficient in Britain and produced enough energy to light the streets, run the trams and meet the domestic energy requirements for all of Edinburgh. Fuel was transported from the collieries to the power station by a direct rail link and conveyer belt that ran underneath Portobello High Street. As well as supplying the energy to run its popular wave-making machine, waste water used to cool the power station's generators was used to heat the bathing pool's icy contents. Portobello Power Station eventually became surplus to requirements in the 1970s. Closure took place in 1977, with demolition following soon after.

Opposite below: A crowded Portobello Beach and promenade on a sunny day on 1957. The Portobello pottery kilns can be seen in the background. (*Photograph courtesy of Danny Callaghan*)

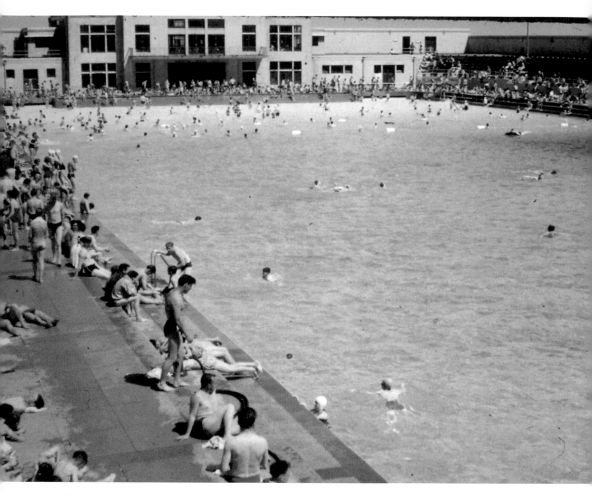

A busy day at Portobello Open-Air Pool in 1958. Crowds flocked to spend the day at Portobello Open-Air Pool if the weather was right. (*Photograph courtesy of Danny Callaghan*)

In the 1950s, when air travel was strictly first class, a holiday abroad was expensive and only a dream for most people. Few people had cars and a holiday closer to home was the most that many people could manage. In Edinburgh, the local resort of choice was Portobello, a cheap and easy tram ride away for most.

Portobello, Edinburgh's 'bracing seaside resort', with its promenade, wide sandy beach, funfair, donkey rides and massive open-air swimming pool, was a thriving holiday resort at the time – the perfect setting for an enjoyable family day out. Popular with Edinburgh residents and visitors from Glasgow during the trade holidays, it would be standing room only when the sun came out.

Portobello Bathing Pool, famous for its distinctive Art Deco design, lofty diving boards, artificial waves and chilly waters, was Portobello's main attraction for over forty years. The pool, which opened in 1936, was the largest outdoor facility of its kind in Europe. The pool was enormous: 330 feet long by 150 feet wide – the equivalent of two Olympic sized pools – and varied in depth from 1 foot to 6 feet 2 inches at the deep end. Six thousand

spectators could be accommodated, with 2,000 seats available under a cantilevered stand, and there were lockers provided for 1,284 swimmers. Exactly 1.5 million gallons of water required to fill the pool were filtered from the sea and heated to a temperature of 68 degrees Fahrenheit by steam from the adjacent power station – though most accounts of the water temperature ranged from icy cold to sub-Siberian.

The pool's great innovation was the first ever wave-making machine in Scotland. This consisted of four 24-foot-long pistons mounted in a chamber at the deep end of the pool, which were arranged to send 3-foot-high waves in three possible directions. These artificial waves were so dramatic that the machine was only operated after a warning on a klaxon had been sounded.

The pool was closed for six years during the Second World War and had to be camouflaged to stop it being used as a landmark by enemy planes. It reopened in June 1946 and, unperturbed by the icy water conditions, the 1950s saw visitor numbers soar during the summer months, with the entrance queue often stretching the full length of Westbank Street. In the early part of the decade, Sean Connery could be found at the pool acting as a lifeguard.

By the end of the decade, Portobello's popularity had waned, as cheap package trips abroad became more readily available and people looked for more exotic locations for their holidays. The pool fell into a long and controversial decline, with the closure of the power station in 1978 removing what little heat there was for the water. The 1979 season turned out to be the last and demolition was finally approved in 1988.

In the 1950s, many cafés and restaurants closed in the evening and those that were open would have been beyond the price range of most people. Going to the pictures was one leisure activity that cut through class divides and was in its heyday in the early part of the 1950s. The main feature and the 'B' film would be viewed through a haze of hanging cigarette smoke caught in the beam of the back projection.

In 1939, the number of cinemas open in the city was thirty-six. They had a total seating capacity of approximately 45,000 (The Playhouse, with 3,300 seats, was the largest in the city), so assuming an average of two performances a day, they could have accommodated the entire population of the city in a week. Cinema-going reached its peak in the immediate post-war period and in the 1950s, there were dozens of cinemas operating in Edinburgh and most people would have made a weekly visit to the pictures. They were also the venue of choice for a first date.

In 1955, the film *Blackboard Jungle* featured Bill Hayley and the Comets' song *Rock Around the Clock*. The film popularised rock 'n' roll and triggered a period of teenage rebellion. When it was shown at a London Cinema in 1956, the Teddy Boy audience began to riot, tearing up seats and dancing in the aisles. After that, disturbances took place around the country wherever the film was shown.

The film industry was not slow in catering for the potential of newly affluent teenagers as a mass market for their product and started to produce films that reflected and catered for their interests and attitudes. *Rock Around the Clock* was one of the major box office successes of 1956, and many more rock 'n' roll films soon followed. *Rebel Without a Cause*, featuring the iconic James Dean in his most celebrated role, was the story of a rebellious teenager at odds with his parents.

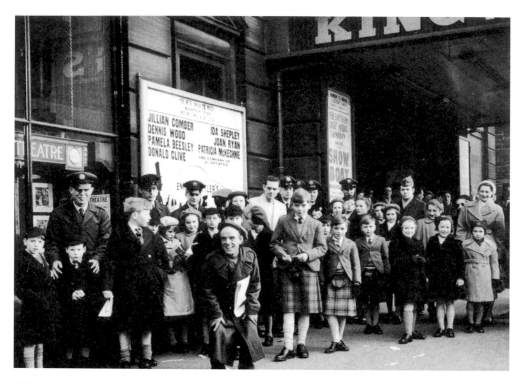

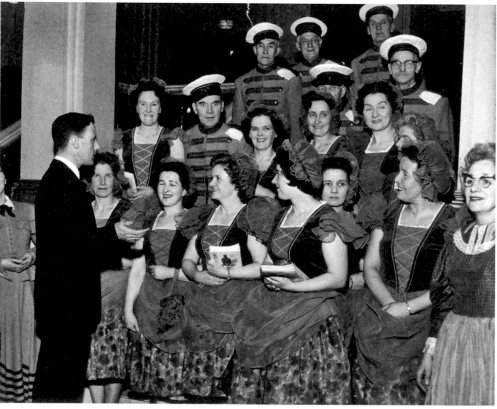

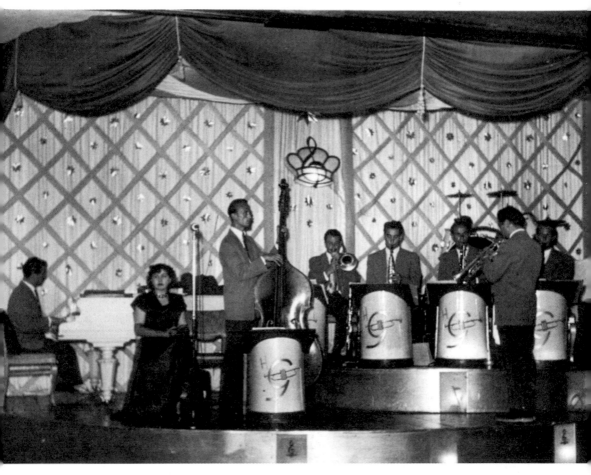

Above: A dance band on the revolving stage at the Palais de Danse, Fountainbridge. (*Photograph courtesy of Seonaidh Guthrie & LMA*)

Opposite above: A happy group outside of the King's Theatre on Leven Street. The men in uniform are military personnel from the American airbase at Kirknewton. During the 1950s, the King's Theatre became the natural home of pantomime and variety shows in Edinburgh. Stanley Baxter, Jimmy Logan, Andy Stewart and the Alexander Brothers were all major audience pullers. It also witnessed the first performances of Rikki Fulton and Jack Milroy as the renowned Francie and Josie double act. (*Photograph courtesy of Seonaidh Guthrie & LMA*)

Opposite below: A group of King's Theatre ushers and usherettes are briefed before a pantomime performance. (*Photograph courtesy of King's Theatre Archives, photographer unknown*)

Edinburgh features as the setting for the 1959 film *The Battle of the Sexes*, starring Peter Sellers and Constance Cummings. The comedy tells the story of an American female businesswoman who tries to make changes to the old school management of a traditional Edinburgh company. It makes unusual use of Edinburgh locations, with the Royal Scottish Academy building as a railway station and the Holyrood Park standing in for the Highlands.

The introduction of television in Scotland in 1952 brought the little screen into the home; for many it was no longer necessary to leave the fireside for a night's entertainment. Hollywood recognised this and made a desperate attempt to make cinema-going more interesting by reintroducing 3D movies in 1952 (3D had been around as far back as 1922 but had fallen out of favour). The 1952 film *Bwana Devil*, with man-eating lions jumping out of the screen, started the 3D craze of the 1950s and they were very popular for a time. The problem was that if the film wasn't projected accurately the result was blurry and people complained that they caused headaches. Sitting in the cinema in funny specs must have also put many people off and when widescreen Cinemacope was introduced, the 3D craze soon fizzled out.

Going out dancing was one of the most popular forms of social entertainment in the 1950s. It provided the opportunity for a bit of romance and thousands of married couples first met while dancing.

Dancers were well catered for with numerous dance halls, such as The Palace Ballroom on Princes Street, The Eldorado in Mill Lane, Fairley's Dunedin Assembly Rooms on Constitution Street, the Silver Slipper in Springvalley Gardens, the Plaza in Morningside and The Locarno Ballroom in Slateford.

The biggest and most sumptuous was the Palais de Danse in Fountainbridge. The Palais opened in 1920 and in its early days, when it was the most upmarket dance venue in the city, it was visited by the Duke of Windsor and the Duke of Kent.

The Palais was enormous, with space for 3,000. The great novelty was the revolving stage, which allowed bands to change with no interruption to the dancing. There were no alcoholic drinks – the 'cocktail bar', Cupids Corner, served only fruit juice. Local lads attending the dancing had stiff competition from American Air Force personnel who were stationed at Kirknewton in West Lothian during the 1950s.

The Palais is often associated with Sean Connery, who was born in a 'single-end' in the Fountainbridge area in 1930. Before gaining international stardom, he worked in McEwan's Brewery, as a co-op milkman, a French polisher, a coalman, a male model, a lifeguard at Portobello Pool and a bouncer at the Palais de Danse.

Going to the dancing became less popular with the advance of television ownership; attendance at city dance halls dropped by 50 per cent by the end of the decade.

6

SHOPPING
& MARKETS

With increased affluence during the 1950s, shopping became less of a chore and more of a reason for a day out – 'going shopping' was much more pleasurable than 'doing the shopping'. Large department stores, which flourished during the decade, offered a wide range of goods for sale, and a shopping trip could be completed with a bite to eat, often accompanied by the strains of a string quartet, in a restaurant attached to the store or in a Crawford's tea room.

Popular department stores in the 1950s included: R. W. Forsyth and Binns on Princes Street, J&R Allan and Peter Allan on South Bridge, Parkers on Bristo Street and the mighty Jenners.

Throughout the 1950s, most shopping for fresh ingredients was done on a day-to-day basis in local shops – many of which would have been run by one of the retail co-operative societies. In 1950, 10 per cent of all shops in Scotland were owned by retail co-operative societies, and most day-to-day shopping was done in the shops of Edinburgh's two large co-operative societies: St Cuthbert's and Leith Provident.

> We opened with considerable spirit and enthusiasm, and some of us found new relish in our butter, ham, and meal, in that it was turned over to us from our own shop, through our own committee. We were all yet working-men, but we began to have the feeling that we were something more, and would soon be business men, reaping profits we had for long been sowing for others.
>
> Quote by original St Cuthbert's Co-op member, 1859

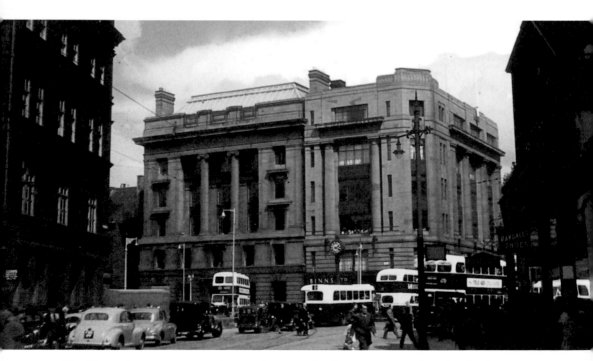

The Binns department store is prominent in this busy scene on Shandwick Place in 1954. (*Photograph courtesy of George Angus*)

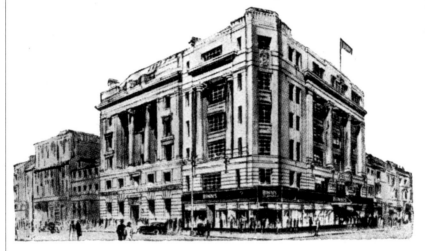

A 1950s advert for the Binns department store – 'A Delightful Friendly Place' The clock outside the Binns department store at the west end of Princes Street was a popular meeting place.

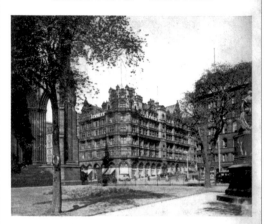

SCOTLAND'S
most fashionable
SHOPPING CENTRE

Gathered together in this streetful of shops under one roof you will always find the **good things**. To-day—as it has been for more than one hundred years—Jenners is synonymous with excellence.

A 1950s advert for Jenners – 'Scotland's most fashionable shopping centre'. In the 1950s, Jenners was unarguably Edinburgh's best-loved shop and was the oldest surviving independent department store in the world up until 2005. It began life in 1838 when Charles Kennington and Charles Jenner were sacked from their jobs as Edinburgh drapers for attending the Musselburgh races rather than turning up for their shifts. They promptly purchased the lease on a converted townhouse property on the corner of Princes Street and South St David Street with a view to starting their own drapers. On 26 November 1892, disaster struck when the original store burnt to the ground. The new building has been a Princes Street landmark since it opened on 8 March 1895.

In the 1950s, St Cuthbert's Co-op was a proud Edinburgh institution, employing many thousands of people. Co-operative societies allowed customers to obtain membership, effectively becoming stakeholders in the company, meaning that the business could be tailored to suit the economic interests of the consumer rather than the store owners. Each customer was assigned their own specific five- or six-digit dividend number, or 'divi', which would see them receive a remuneration at the end of the financial year based upon how much they had purchased and how much profit the Co-op had made as a whole.

The first St Cuthbert's Co-op store opened on 4 November 1859 on the corner of Ponton Street and Fountainbridge, and sold a wide range of consumer goods. The association initially had sixty-three members and capital of just over £30. The name was derived from St Cuthbert, the patron saint of Northumbria. The presence of the patron saint in Scotland's capital has been in evidence for many centuries; the foundations of St Cuthbert's parish church near present day Lothian Road are said to date from as early as AD 850.

By 1880, the Co-op was proving to be a huge success and was looking to expand. A new headquarters was opened in Fountainbridge in order to cope with the increase in trade and membership. Located on the main road conveniently close to the Union Canal, the new turreted, baronial-style premises were an impressive sight. 'The Store'

as it was commonly referred to, was becoming famous for its ability to provide a vast array of high-quality services. St Cuthbert's would go on to boast a large-scale dairy with daily horse-drawn milk deliveries, a bakery, a butchery, a tea room, a department store, a laundry and carpet-cleaning service, a carriage works, land and property letting operations and a funeral services department. In addition, the company owned thousands of acres of farmland. Further expansion saw St Cuthbert's Co-op merge with other local and national societies, and by the end of the First World War the company was the largest co-operative in Scotland. The co-op boasted the highest sales in the UK, paying out an incredible £4 million in dividends, as well as being the single biggest ratepayer in the city of Edinburgh, with multiple branches across the capital.

In 1944, a thirteen-year-old local Fountainbridge lad by the name of Thomas Sean Connery earned his first wage of 21s a week as a barrow worker at the Association's dairy in Corstorphine. Sir Sean, or 'Big Tam' as he was then known, left St Cuthbert's in 1948 to do his National Service, but returned the following year and worked as a milk horseman for the enhanced wages of £3 15s 6d per week. He remained with the company until January 1950, before eventually finding fame and fortune as the first James Bond. If any of the local hyperbole is to be believed, then Sir Sean once delivered milk to almost every household in Edinburgh.

St Cuthbert's pioneered self-service shopping in Scotland, testing the water with an experimental self-service shop at Dundee Street in 1949. New ground was also broken when St Cuthbert's opened Edinburgh's first American-style supermarket store on Leven Street, Tollcross, during its centenary year in 1959. The gates of the goods entrance still bear the letters SCCA (St Cuthbert's Co-operative Association), despite the store changing name many years ago. The finale of the centenary year was a children's gala day at Stenhouse, which featured rides on the Association's carriages and horses and goodie bags, which included a special celebratory badge.

In 1966, St Cuthbert's become the sole co-operative in Edinburgh, as the company completed the takeover of five of its biggest rivals including the famous Leith Provident society. Over 3,000 employees were now under the control of St Cuthbert's Co-operative Association Ltd.

St Cuthbert's changed its name to the Scottish Midland Co-operative Society, or Scotmid for short, in 1981 after amalgamating with Dalziel of Motherwell. The name change reflected the company's intention to expand further across the nation. Sadly, the sight of milk deliveries by horse and cart came to an end soon after. Never again would the morning milk delivery be accompanied by the clip-clop of hooves. 26 January 1985 marked the last ever day of horse-drawn milk floats in Edinburgh after 125 years.

Today, despite significant competition from rival supermarkets, Scotmid goes from strength to strength as it continues to focus on a wide range of services. It is Scotland's largest and best known co-operative, continuing a long-standing and proud tradition, with more than 300 stores and 5,000 employees nationwide. Scotmid chose to move from the historic B-listed headquarters in Fountainbridge in 2005 to a purpose built home at Newbridge. A café and restaurant now occupy the 133-year-old original Fountainbridge co-op premises.

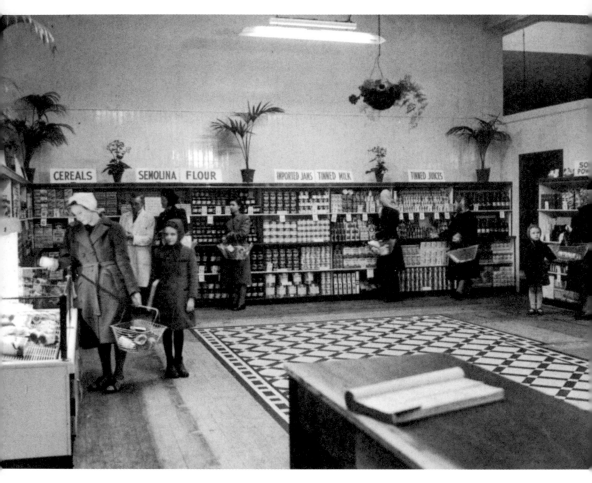

Above: St Cuthbert's first experiment in self-service at the Dundee Street branch in 1949. (*Photograph courtesy of Scotmid*)

Opposite above: The opening day of St Cuthbert's, and Scotland's, first fully operational supermarket in Leven Street in 1959. Customers came to appreciate the convenience of self-service, although many missed the sociability and personal service of the traditional small shop. (*Photograph courtesy of Scotmid*)

Opposite below: The last days of the St Cuthbert's milk delivery by horse-drawn cart. (*Photograph courtesy of Scotmid*)

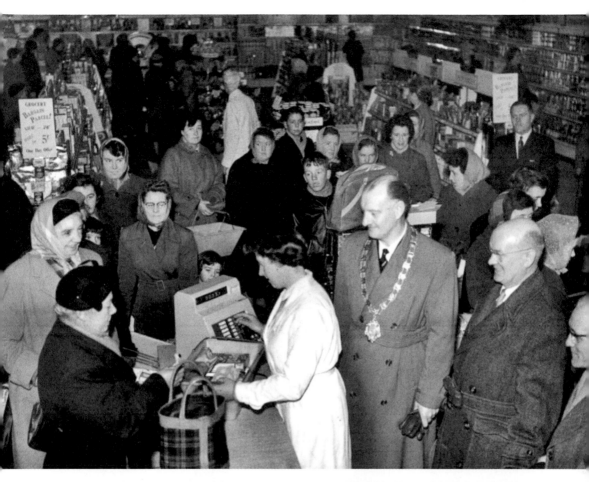

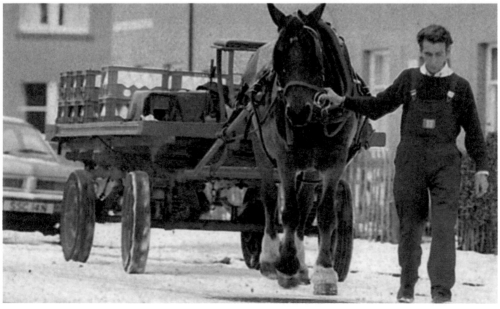

The Woolworths store at the east end of Princes Street decorated with flowers and flags for a Royal visit. (*Photograph courtesy of Sarah Knight & LMA*)

In 1956, Woolworths expanded their store at the east of Princes Street to take in the former Palace Picture House premises immediately to the west. After this no Saturday afternoon would have felt complete without a visit to the 'Big Woolies'.

Woolworths opened its iconic purpose-built Princes Street store in March 1926 in front of a large crowd. Its modern, solid-looking design featuring a distinctive octagonal tower is thought to have been the work of the company's in-house architect, W. Priddle. The store was intended to be the flagship Woolworths in Scotland and its prime location on Princes Street opposite the North British Hotel and the notoriously windy steps of Waverley station helped it to quickly become an Edinburgh landmark.

The block had previously been the location of the first ever residential property to appear on Princes Street in 1769. The eighteenth-century building was later transformed into the Crown Hotel before work on Woolworths began in 1925.

Woolworths had been operating on these shores since 1909, when the company's founder, Frank Winfield Woolworth, fulfilled a long-time desire to expand his successful 'five and dime' business venture out of North America by opening a store in Liverpool. Mr Woolworth was a retail pioneer who believed in selling a lot for a little as opposed to selling a little for a lot, and is credited with creating the modern retail model that many stores still follow today. By the time of Frank Woolworth's death in 1919, the forty-year-old business empire had grown to an incredible 1,200 stores worldwide and boasted the world's tallest building as its American headquarters.

The Woolworths on Princes Street survived until 1984, when the company's new owners decided to close a number of the larger stores around the UK. The Princes Street store closed despite its city centre location and status as the most profitable Woolworths branch in Scotland at that time.

In 2008, Woolworths went into administration and the company's presence on the British high street came to an abrupt end just a year shy of its UK centenary. The closure of Woolworths' 200 UK stores left more than 27,000 unemployed.

Located within a slice of the wide gorge between Princes Street and Waverley railway station, the Waverley Market, the Victorian predecessor of the Princes Mall, was once the city's premier vegetable and fruit market.

Construction began on the building in 1874 on a compact strip of land to the north of Waverley train station in the valley below Princes Street. An extensive vegetable and livestock market had existed on the site many years before this, but the 1866 expansion of the train station meant that a rethink was required. The architect of the original market's replacement was Robert Morham who made good use of the available space by designing a large U-plan hall with an elegant, symmetrical street level roof garden, which faithfully preserved the popular vistas of the Old Town. The cast-iron structure of the multi-purpose market and exhibition space boasted innovative design features for its time, such as the several sunken glazed shafts incorporated into the roof. These glazed shafts, coupled with numerous glass walls on two of the market's sides, allowed much needed light to filter through into the spacious hall, which was built at a considerable depth. The attractive roof garden, which could be accessed via Princes Street, was supported by a central row of cast-iron columns and was maintained exquisitely during the market's early years. During the era of horse-drawn transport, a coach and omnibus stand was situated on Princes Street outside the market. Buses continue to stop in the same place today outside the current Princes Mall.

Ornate railings surround the roof of Waverley Market in this quiet Sunday morning picture from 1958. (*Photograph courtesy of George Angus*)

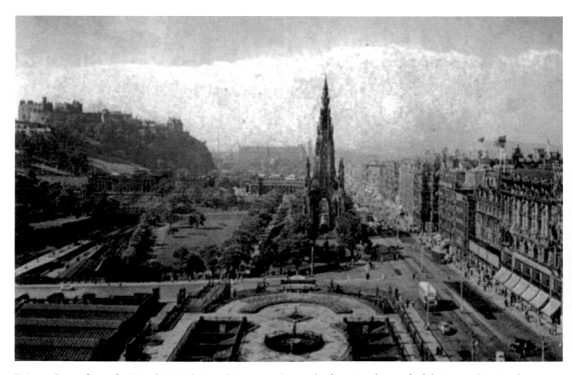

Princes Street from the North British Hotel. View to the castle showing the roof of the Waverley Market, Forsyth's Department Store and the C&A building. (*Photograph courtesy of Evelyn Muir & LMA*)

The decline of retail markets coincided with the increase in the number of shops during the 1950s and, in the latter part of the decade, the number of traders using the market dropped significantly. Waverley Market at the time became synonymous with hosting popular fairs and exhibitions.

Various large-scale events such as the Ideal Homes exhibition, flower shows, dog shows, car shows and even circuses and carnivals all took place within the spacious underbelly of the Waverley Market over the years. However, by the early 1970s, the fortunes of the once grand Victorian arcade were in sharp decline. The roof garden, which had always been maintained to the highest possible standard, was no longer tended to as the structure was now deemed to be unsafe. In 1974, a century after work began to build it, the Waverley Market's demolition was well underway.

The Edinburgh Meat Market opened in 1884 on the corner of Fountainbridge and Semple Street. It followed the creation in 1852 of the city's first municipal slaughterhouse, which was located opposite on the site of today's Tollcross Primary School. The slaughterhouse was fed by the cattle market at Lauriston Place close by.

Prior to the slaughterhouse at Fountainbridge, many of the city's abattoirs and meat markets had been located on and around the slopes of the Old Town, hence street names such as Fleshmarket Close. Effluent from the abattoirs flowed directly into the putrid Nor' Loch. Edinburgh's undergoing expansion and modernisation in 1800s meant that the production of meat had to be relocated away from the city centre in the interests of public health. The area chosen for relocation was Fountainbridge, formerly the site of farmhouses and orchards, but fast becoming the industrial heartland of Scotland's capital since the opening of the Union Canal in 1822.

As the twentieth century approached, the idea of slaughtering cattle close to residential areas was becoming increasingly unpopular. The slaughterhouse was moved in 1909 to a new purpose-built site at Chesser on the outskirts of town. The now redeveloped and extended Edinburgh Meat Market continued to operate on Fountainbridge. Its days, however, were numbered. It too eventually relocated to Chesser in 1921. Inner city meat markets were no longer desirable.

Despite the relocation of the meat market, the building still managed to survive and was even utilised briefly as a meat distribution facility during the Second World War, as the reality of food rationing gripped the citizens of Edinburgh.

The old meat market building was saved from dereliction when it was turned into the Americana discotheque. It would remain as a nightclub for a number of years before changing to the popular Fat Sam's restaurant in 1986. Customers at the Chicago-style diner were given a keepsake in the form of pin badges and stickers emblazoned with 'I survived Fat Sam's'. The 120-year-old structure was demolished in 2007 to make way for the new Exchange Place office development.

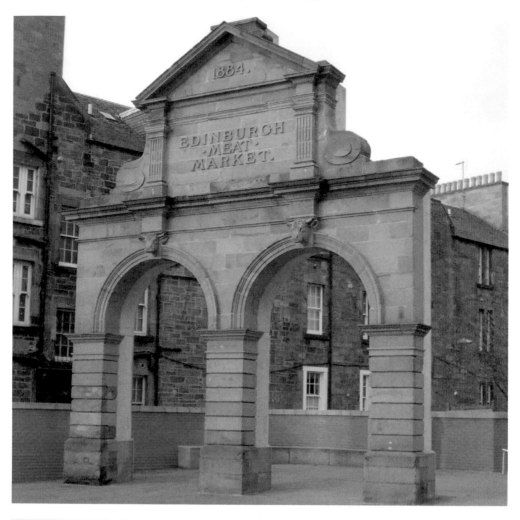

Above: The remains of the old Edinburgh Meat Market remind passers-by of just how much the area of Fountainbridge has changed in recent years. Edinburgh Meat Market and its distinctive arches were designed by architect Peter Henderson. Henderson's smart, classical façade featuring a pair of expertly sculpted bull heads quickly became an intriguing focal point of the street.

Left: The stone-carved bull heads from the meat market were salvaged and restored in 2009. They now stand a little further west from their original location but continue to create an interesting visual feature on the street.

HEART of MIDLOTHIAN
FOOTBALL CLUB LTD

OFFICIAL PROGRAMME

Photo by the courtesy of the "Edinburgh Evening Dispatch"

SCOTTISH LEAGUE

HEARTS v. RANGERS

Saturday, 17th March 1956

KICK-OFF 3.30 p.m

PRICE

3D

Football attracted vast crowds in the 1950s – in the 1956/57 season, the gates for Hearts and Hibernian were 714,000. During the mid-1950s, Edinburgh's football enthusiasts had reason to acclaim their two professional teams. In the first half of the decade, Hibernian became the most accomplished team in the First Division of the Scottish League. Their forward line of household names – Gordon Smith, Bobby Johnstone, Lawrie Reilly, Eddie Turnbull and Willie Ormond – collectively known as the Famous Five were considered to be the best ever forward line in Scottish football and were famed for their attacking style. Together, they scored nearly 700 goals and produced among them more than 100 international caps for Scotland. Their first outing together was on 21 April 1949 and they remained stalwarts of Hibernian until 1955. One of Hibernian's other stars, the goalkeeper Tommy Younger, had to be flown over from his national service posting in Germany at the weekends to turn out for the team.

As the fortunes of Hibernian waned, it was the turn of Heart of Midlothian to have a change of fortune. The team had gone from 1906 to 1954 without a significant trophy. However, the club was to experience the most successful period in its history when Tommy Walker took over as manager in 1951. The side he inherited included the legendary *Terrible Trio* of Alfie Conn, Willie Bauld and Jimmy Wardhaugh. Bauld scored a hat-trick in his first team debut in October 1948, which was the first time that the 'Terrible Trio' had played in the same match. Bauld is considered to be the best Hibernian player of all time and Walker added a number of other skilled players, including 'Iron Man' John Cumming, who played through Heart's win against Celtic in the 1956 cup final with a head wound.

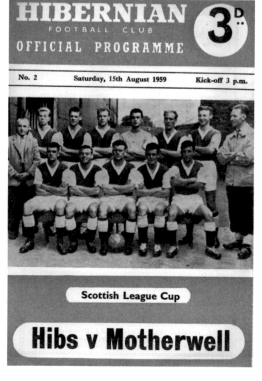

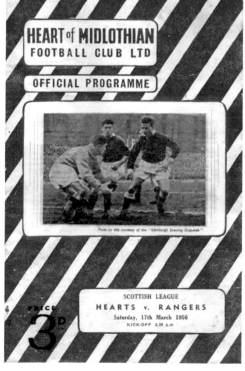

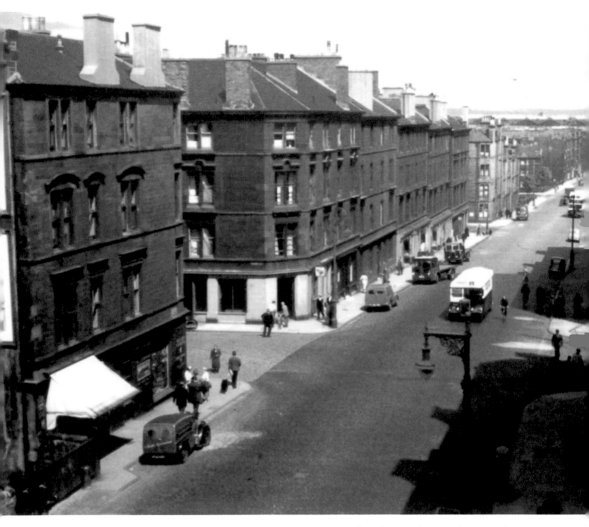

Above: These soot-blackened tenements would have been a familiar sight to Hibernian fans making their way to Easter Road. (*Photograph courtesy of George Angus*)

Opposite left: A Hibernian programme for the match against Motherwell on Saturday 15 August 1959. The line-up of the 'boys who rocked Dundee with a tremendous rally at Easter Road on Tuesday night' is: back row, from left to right: Pat Hughes, John Young, Jackie Wren, George Muir and Tommy Slavin. Front row: John Fraser, Johnny Frye, John Buchanan, Graham Pate and Johnny McLeod. With them are training supervisor Jimmy McColl and assistant trainer Jimmy Cumming.

Opposite right: A Heart of Midlothian programme for the match against Rangers on Saturday 13 March 1956. The 'Terrible Trio' of Conn, Bauld and Wadhaugh are detailed as the front three for the match. Pre-match entertainment was provided by the City of Edinburgh Band and The Butlin Young Ladies' Scottish Display Team presented Stars in Rhythm at half-time.

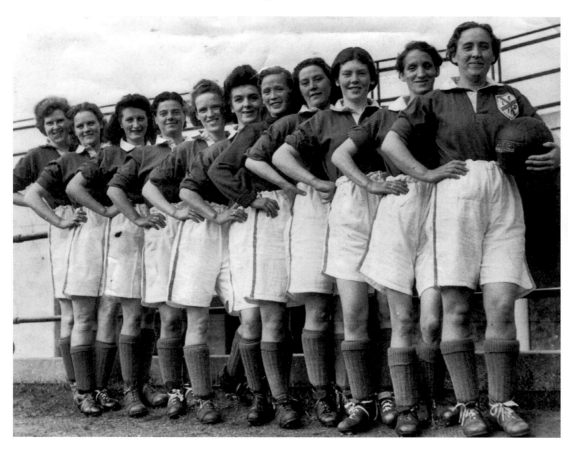

The Edinburgh Dynamos Ladies football team in 1950. This photograph was taken prior to a match between the Dynamos and Bolton Ladies FC at New Meadowbank Stadium in front of a crowd of 10,000 spectators. A newspaper report at the time notes that the men and boys 'Came to Jeer; Stayed to Cheer'. It was the first time since 1939 that an all-women's football match had been played in Edinburgh. The Dynamos lost 6-2, although they had beaten some local junior men's teams. (*Photograph courtesy of Bet Adamson & LMA*)

In 1954, Heart of Midlothian won the League Cup, their first trophy in forty-eight years, and went on to win the Scottish Cup in 1956, then the League title in 1958 and 1960, which ended with Walker being awarded the OBE for services to football.

Speedway racing was a popular spectator sport in Edinburgh during the early part of the 1950s. The Meadowbank Monarchs were re-established in 1948 with their track at Old Meadowbank. Speedway stopped at Meadowbank in 1954, due to a post-war entertainment tax, which made it unprofitable. The entertainment tax was later scrapped, and the sport was reintroduced to Edinburgh in 1960.

Murrayfield has been the base for rugby in Edinburgh since 1925 and also the traditional home of ice sports. Murrayfield Ice Rink opened to the public in August 1952. The building had been built in 1939, but was immediately requisitioned for war purposes as a depot for the Royal Army Service Corps and continued in use by the government until 1951.

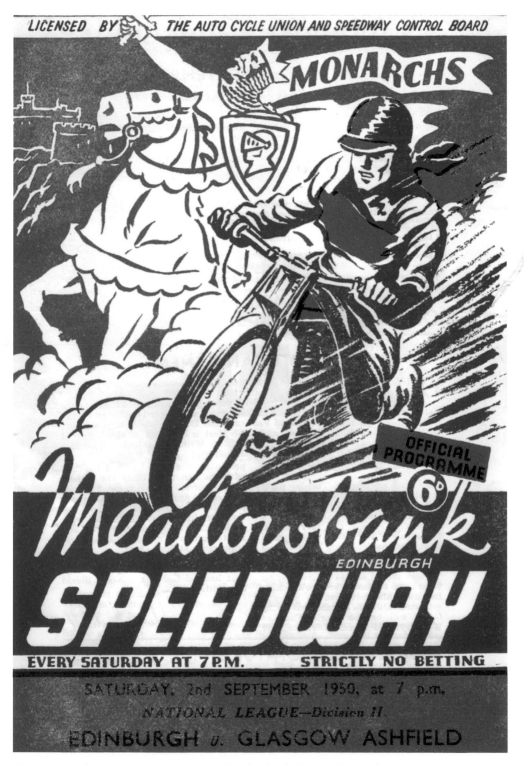

Front cover of a 1950 programme for a Meadowbank Monarchs speedway meet.

During the 1950s, the rink, which was the most modern in Scotland, with its Olympic-sized skating surface, was a major attraction for ice sports and other events. Public skating was the mainstay of the rink and it was also the home of the Murrayfield Royals professional ice hockey team. A variety of other events were also staged, ranging from ice shows, amateur boxing, wrestling and basketball. It was not unusual for crowds of 1,000 skaters to turn up for the weekend skating sessions and in the spring of 1953, 5,000 people attended an international amateur boxing evening with 2,000 having to be turned away. There were also capacity crowds for professional ice hockey during the 1950s. However, the sport fell out of favour by the end of the decade and the professional league was disbanded.

Edinburgh's second ice rink at Haymarket was the traditional home of curling in the 1950s.

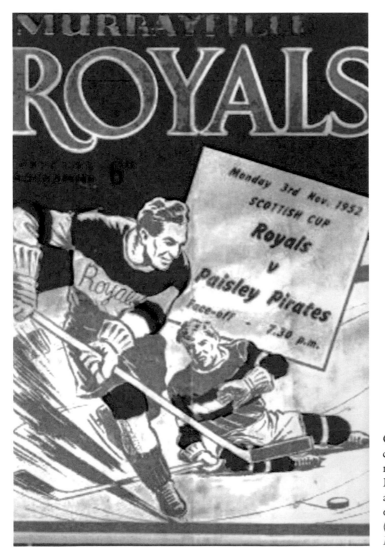

Official programme cover for an ice hockey meet between the Murrayfield Monarchs and the Paisley Pirates on 3 November 1952. (*Photograph courtesy of Murrayfield Ice Rink*)

8
WORKING LIFE

It is difficult today to imagine Edinburgh as an industrial city, but in the 1950s, at a time when not every home possessed an alarm clock, the sound of work klaxons going off at the start and end of the working day was a common one. The main industrial areas at Leith and Granton, along the railway lines from Abbeyhill to Portobello and Haymarket to Sighthill, and along the Forth & Clyde Canal were typified by railway sidings and tall mill buildings.

Brewing and printing have a long history and particular association with Edinburgh, and were part of a thriving industrial base in the 1950s. To this could be added biscuit-making, hence the maxim that Edinburgh was known for the three Bs: Beer, Biscuits and Books.

Throughout the history of Edinburgh, brewing takes its place as one of the most important and oldest industries. The origins of brewing go back to the twelfth-century monks of Holyrood Abbey, who took advantage of the clear spring water for the production of their ale. In the eighteenth century, when Edinburgh set taxation on ale (in addition to the government's malt tax), Holyrood ales were unaffected as the production centre lay outwith the city.

The breweries of Edinburgh contributed to more than just the economy of the city; beer production led to pillars of smoke from the brewing industry, and played their part in the city's nickname 'Auld Reekie'. At the turn of the nineteenth and twentieth century, thirty-five breweries were producing ale. Among them were the highly successful firms of William Younger, who had started business in 1749 in Leith, later moving to the Holyrood aream and William McEwan who founded the famous Fountain Brewery in 1856.

William Younger and William McEwan owed much of their early success to the popularity of their beers overseas. English Brewery companies eyed enviously the Edinburgh trained brewers, who were much sought after. William Younger and William McEwan combined in 1930 to form Scottish Brewers.

After the Second World War and particularly in the late 1950s, radical changes occurred in the production and distribution of beers. This was accompanied by frequent amalgamations and takeovers involving many smaller brewers. By the 1950s, McEwan's had become the dominant party in the McEwan/Younger venture, and a full merger was undertaken in 1959. The Abbey Brewery, previously Youngers Brewery, was closed down in 1956 and converted to flats. The mighty Scottish and Newcastle formed in 1961 originated from the combination of the humble McEwans and Youngers breweries.

With the closing of the Fountain Brewery in the late 1990s, nothing is left of these great breweries but smaller companies remain and new ones aspire to reach the successful heights of the beers of the past.

Another key area of manufacture in the 1950s was the biscuit. In 1951, about 2,700 people were employed in biscuit production in Edinburgh. This figure continued to rise throughout the 1950s and contrasts with the decrease of workers in bread and flour confectionary production. Amazingly biscuit production rose so fast that biscuit making reached second place, next to brewing and malting in the city's food and drink production sector. At the end of the 1950s, around 70 per cent of the workforce in biscuit manufacturing was female.

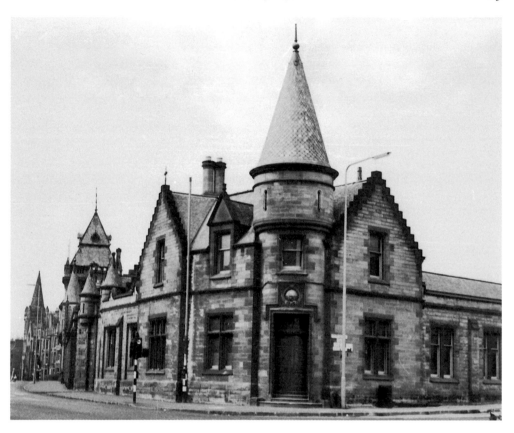

Above: The Baronial frontage of Thomas Nelson's Parkside print works on Dalkeith Road. The building was closed in 1968 and later redeveloped as the Scottish Widows Fund and Life Assurance head office.

Right: Advert for Younger's Beer, featuring the Father William trademark.

McVitie and Price employed over 500 workers by the end of the 1950s and William Crawford around 700. Both belonged to the United Biscuit group. The Weston Biscuit Company had its original factory in Slateford but moved in 1958 to a new centre of production, Burtons Gold Medal Biscuits, on the Sighthill Industrial Estate. Workers at the old Slateford factory benefited from the payday offer of a bag of loose biscuits or chocolate covered mallow teacakes for a shilling.

William Crawford & Sons of Leith were the oldest Scottish biscuit manufacturers. The origins of the company stretch right back to 1813, when William Crawford opened a small shop at the Shore in Leith. These premises quickly became too small for business and a new factory was opened at Elbe Street, which was the centre for the production of Crawford's nationally renowned shortbread. Crawford's shortbread and biscuits have attained a national reputation, and have become widely known in some of the remotest parts of the globe.

Printing was historically one of Edinburgh's main industries, and in the 1950s the publishing industry employed between 5,000 and 7,000 people in the city. Thomas Nelson's Parkside Works was one of the biggest. Thomas Nelson opened a second-hand bookshop in Edinburgh's Old Town in 1798 from which he started to publish inexpensive reprints of classic books. This proved profitable and his sons, William and Thomas, entered the business in the 1830s. In 1845, they established a printing house at Hope Park; this building burnt down in 1878, and by 1880 they had moved to a new building on Dalkeith Road.

In the early part of the twentieth century, Thomas Nelson & Sons were the most successful publishing company in the world, with up to 400 people being employed at their Parkside Works on Dalkeith Road. It was a close-knit family firm and provided a range of social and welfare facilities for its workers, including an institute and a bowling club. By the 1950s, the company had moved away from their traditional base of cheap reprints into the textbook market, and they exported all over the world.

Printing methods remained virtually unchanged until the revolution of offset lithography in the 1950s, which standardised print production and, as it became cheaper to print abroad, Edinburgh's printing industry almost disappeared. In 1968, the printing division of Nelsons was sold and the Parkside Works were demolished to make way for the offices of the Scottish Widows Insurance Company.

The largest concentration of rubber production mills in the country was located in Edinburgh during the early 1950s. In 1951, the North British Rubber Company at its Castle Mill Works in Fountainbridge employed over 4,000 workers and was the largest employer in the city. Production lines included: golf balls, clothing, hot water bottles, hoses, floor mats and tyres. The company was also involved in early recycling – converting scrap rubber into new products on a large scale.

Over the years, just about everything that can be made of rubber has been made by the factory and, in 1914, North British Rubber was able to furnish a room at an International Rubber Exhibition with nothing but rubber.

Throughout both World Wars, the company provided huge quantities of essential products including tyres, boots, gas masks and fabric for barrage balloons. The firm was capable of making 2,750 pairs of boots a day, and produced a staggering total of 1,185,036 pairs during the First World War and 7 million gas masks during the Second

World War. The Wellington boot was an object of envy by the German soldiers during the Second World War and it contributed to the British Army's success.

In the 1950s, the North British Rubber Company, exhibiting a degree of self-interest, firmly supported the introduction of motor buses to replace Edinburgh's tram system – the trams did not require rubber tyres for their wheels. In 1958, the company was responsible for producing the first traffic cones for use on the M6.

The final years of the 1950s presented an overall decline in the Edinburgh's rubber industry. Competition was fierce and the smaller city companies disappeared throughout the decade, the result of takeover and liquidation. By 1960, the only two surviving companies were the North British Rubber Company and the India Rubber Company located on Leith Walk. The North British Rubber Company works at Fountainbridge closed in 1967, with the opening of the Uniroyal Plant at Newbridge.

By the end of the 1950s there were two collieries operating within the City Boundary, one at Newcraighall and the other at Gilmerton. The latter would close in 1961 following a major fire. Coal had been dug for years in the Newcraighall area, but it was not until 1827 that the Village first appeared on the map. The opening of the 'Klondyke' seam at Newcraighall in 1897 secured the village's future, with 1,000 workers being employed in the production of 1 million tons of coal per year by the 1920s. Generally the scale of this workforce continued up to the 1950s but reduced to 700 by 1963 with the implementation of an improvement scheme. The colliery closed in 1968 because of geological problems.

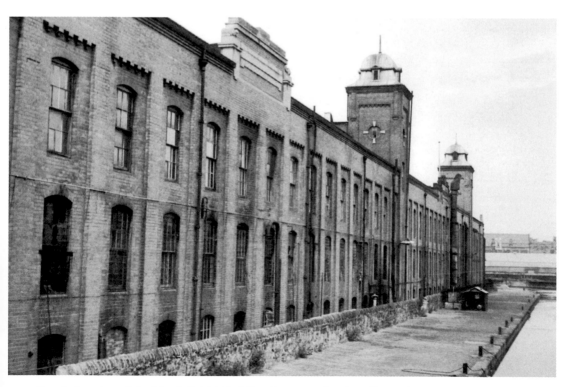

Canal elevation of the North British Rubber Company Castle Mills Works at Fountainbridge.

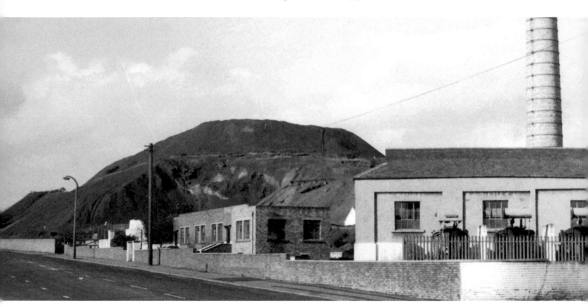

Newcraighall Pit. The colliery that was sunk at Newcraighall in 1897, to develop workings beyond the shore of the Firth of Forth at Musselburgh, promised work and wages for a hundred years – a miner's equivalent of striking gold – and the pit became known as the 'Klondyke'.

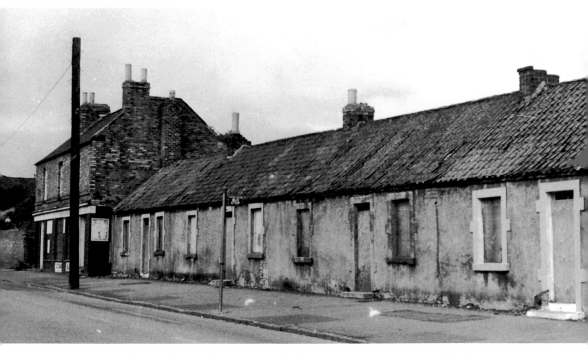

Housing associated with the nearby Newcraighall or Klondyke pit. Newcraighall was the setting for the film *My Childhood* by Bill Douglas. The Bill Douglas Trilogy of films, which feature Newcraighall, paints a bleak picture of the village in the post-war period and marked the start of British alternative cinema.

VOL. XL. No. 1 JANUARY 1955

MECCANO
MAGAZINE

9
CHILDHOOD

LEYLAND TITAN

The 1950s was a dangerous time for children. They survived being born to mothers who mostly smoked and/or drank while they carried them. Baby cots were covered with bright coloured lead-based paints. There were no childproof lids on medicine bottles, doors or cabinets; bikes were ridden without helmets and there were no seat belts or airbags in cars. They spent the bulk of their lives outdoors, in all weathers, fell out of trees and came home with grazed knees. Despite a diet of cream cakes, white bread, real butter and gobstoppers few children were overweight, because they were outside playing and there were no mobile phones for parents to check up on them.

The reactionary mood of the 1950s urged women back into the home after the temporary freedom of the war. This meant that few mothers of young children went to work and most preschool children stayed at home, so school at the age of five came as a bit of a shock. Parents and teachers were regarded with a degree of awe and there was no answering back. There was fairly strict discipline at school – the Lord's Prayer was recited every morning and any misbehaviour resulted in a smack with the ruler or the belt. Yet there was a lot more freedom to wander and play.

Television was still in its infancy in the early part of the 1950s and the days of universal television ownership were still a long way in the future. This, however, was not an issue for children as they were able to play in the street without the obstacles of traffic and parked cars. There were even children's play streets with vehicles banned between 4 p.m. and sunset.

The children's street games and songs of the period are charmingly captured in *The Singing Street*, a short film made in 1950 by teachers from Norton Park School in Edinburgh. The aim of the film was 'to show how the games are played – in their natural setting', and children from the school were filmed at various locations singing songs and playing skipping and ball games that were part of a long oral tradition in Edinburgh. Most of the games had been lost to school playgrounds within a decade, and the film is a record of a more innocent and vanished time in children's history.

Notes accompanying an issue of the film explained that 'The rhymes vary from street to street and change from day to day. What is old seldom dies yet there is always something new appearing. The word is accepted and the poetry is kept alive. No one asks: What does that mean?'

IN AND OUT THE DUSTING BLUEBELLS

To play, one player would be chosen as 'on' while the rest of the players formed a circle and raised their hands to create arches. The player who has been chosen as 'on' would then dance through the arches singing: 'In and out the dusty bluebells, Who shall be my master?' The player would then stand behind one of the circle and tap another player on the shoulder while singing: 'tippitty tappitty on your shoulder'. The chosen player would then link onto the first player and begin the song again, weaving through the arches. This would continue until a single player was left.

One of the adult onlookers in the film is Cllr Pat Murray, who was a collector of children's toys and the prime instigator in the establishment of Edinburgh's Museum of Childhood, which opened in 1955. It was the first museum in the world to specialise in the history of childhood and remains a popular attraction.

With its courts and closes, a castle, a paddling pool beside St Margaret's Loch in Holyrood Park and Princes Street Gardens, Edinburgh Old Town had unbeatable attractions for city children at play.

During the 1950s, it was the tradition of children on 5 November and 25 May to build enormous bonfires in the courts and closes of the Old Town. These looked like mutinous barricades made up of old tables, chairs and other flammable waste. However, in 1961 the Corporation decided against such revels, and all bonfire material was removed by the dustmen. Before that, in 1959, children had set fire to the Castle Rock, where the grass at the time was tinder dry. It was an enormous success – the fire brigade had to be called, which added greatly to the children's fun.

These activities were fuelled by ha'penny chews, gobstoppers and crisps, plain only with the salt in a twist of blue paper at the bottom of the bag. Barrat's sweet cigarettes made of a sickly sweet substance with a red end and liquorice pipes allowed children to mimic the smoking habits of many of their elders.

Favourite toys for boys were Meccano (in metal), Hornby train sets, Airfix models, chemistry and conjuring sets, and dinky toys. Corgi's range of model cars, in innovatory boxes with clear windows, went on the market in 1956 and were an immediate success, winning the Queen's Award to Industry. Girls were more limited to dolls and prams. Board games were universally popular, and most homes would have had a Tiddly Winks, Ludo, Snakes and Ladders or Monopoly sets. Comics were hugely popular and there were dozens to choose from.

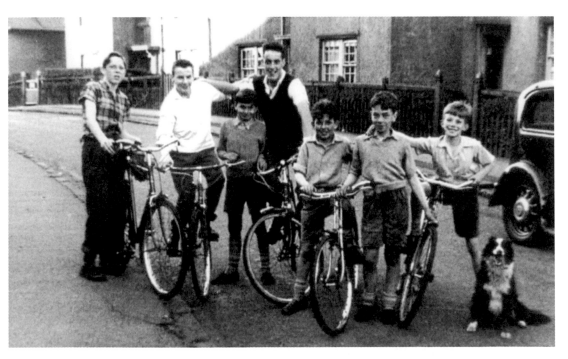

A group of kids with their bikes on Northfield Crescent in the summer of 1959. Boys did not tend to graduate to long trousers until around age twelve. (*Photograph courtesy of Ronnie Dunbar & LMA*)

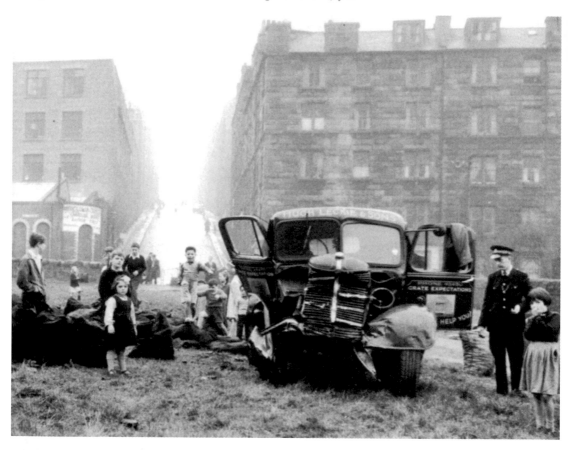

Above: A large group of Dumbiedykes' kids, under the watchful eye of a policeman, descend on Hugh Leckie & Sons coal lorry (with the company motto – 'Grate Expectations' – emblazoned on the door) after it ran of control down the steep Arthur Street in Dumbiedykes in 1959. A lot of the children had black hands on the day and the fires in Dumbiedykes glowed a little warmer after the event. (*Photograph courtesy of Ron Leckie*)

Left: A young lad shows off his hula-hooping skills. (*Photograph courtesy of Capital Collection*)

Above: Children and adults play street games on Newton Street for Coronation Day, 2 June 1953. (*Photograph courtesy Andrew Vardy & LMA*)

Right: Peter Bottmley reads the *Topper* while his sister, Elizabeth, has a nap at No. 42 Dumbiedykes Road in 1954. The exploits of Dan Dare featured in the *Eagle* and there were a host of other favourites: Lion, Rover, Beezer, Dandy, Girl, Bunty, Sunny Stories, Chick's Own to name a few. (*Photograph courtesy Jean Bell & LMA*)

The 1950s was also a time of crazes both for children and adults – the yo-yo and hula hoop, from the Hawaiian dance its users seemed to imitate, were two that swept the nation for a short time. Setting records for adults cramming themselves into small spaces was another craze that reached Britain in the latter part of the 1950s; the telephone box squash and Mini car squash were the favoured small objects in Britain.

The Edinburgh taxi drivers' childrens' outing was a regular summer event throughout the 1950s. The taxi drivers took time off to treat disabled children to a day at the seaside in their balloon-festooned taxis.

Saturday morning pictures provided unequalled enjoyment for a few pennies. It introduced unforgettable characters such as the Lone Ranger, Zorro and Davy Crockett to a generation of kids. It is estimated that 10 million Davy Crockett imitation raccoon-skin hats were sold following the release of the film *Davy Crockett, King of the Wild Frontier* in 1956.

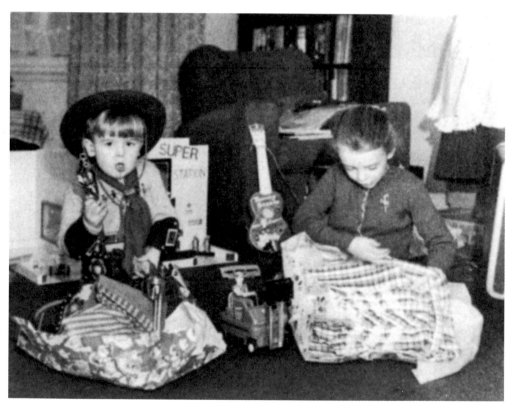

Joan and Stuart Dougan unwrap their Christmas presents in Portobello in 1955. Christmas was a special time in the 1950s, with little crass commercialism. Children didn't doubt that Santa came down the chimney with his sack of presents to fill their stockings, although before the end of sweet rationing, in February 1953, the best Christmas present for most children would have been a small bar of chocolate. (*Photograph courtesy of Joan Dougan & LMA*)

10
CRIME

In spite of a decrease in the population of Edinburgh by 15,000 between 1950 and 1960, the crime rate almost doubled from 6,334 reported offences to 11,188. The major factor in the increase was housebreaking. In 1956, Edinburgh's Chief Constable attributed this to people keeping large sums of money in flimsy safes in their houses and business premises and to the easy temptation of prepaid gas and electricity meters.

Radio-equipped police cars were first deployed to cover Edinburgh's developing suburban housing estates in 1956. This marked the beginning of the end for the beat policeman patrolling local streets and reliance on the distinctive Edinburgh police boxes for communication. The policeman had also lost his whistle by the end of the decade, when it was considered that they were inaudible due to increasing traffic noise.

In 1952, as the Queen's Coronation approached, the Post Office decided to mark the occasion by erecting a new post-box marked EIIR in honour of the new monarch. On 28 November 1952, an official party assembled at the junction of Gilmerton Road and Walter Scott Avenue part of the Inch Estate, the council's newest housing development to formally unveil the postbox.

What at first appeared as a perfectly appropriate recognition of the new Queen quickly became an event that received close attention from the media, caused questions to be asked in the House of Commons and required police surveillance of the postbox. The problem was that Queen Elizabeth I had never been Queen of Scotland and the marking of the box with EIIR was inaccurate and quite unacceptable to some people.

Shortly before the official unveiling of the postbox, a pressure group had written to a number of officials to question the legality of using the EIIR symbol. The authorities were, therefore, aware of the controversy, and five police officers were present at the unveiling ceremony.

Despite the box receiving special police attention, within thirty-six hours the EIIR symbol had been defaced. A week later a parcel containing gelignite was found in the postbox. On 2 January 1953, a postman found another explosive charge. All was quiet for the next few weeks until, on 7 February, two workmen saw a man vandalising the box with a sledgehammer wrapped in a sack. The attacker ran off and the damaged pillar box door had to be removed for repair.

Finally, on 12 February 1953 at around 10 p.m., the area was rocked by an explosion that could be heard a mile away. The postbox had been completely blown apart. The next day a small Lion Rampant was found on the ruins of the postbox. Within two days a new postbox appeared with no sign of EIIR.

The issue was debated in the House of Commons, but there was no conclusive decision on the use of EIIR. The events had alarmed local residents, and they made it clear that for safety reasons the erection of another box with the identification EIIR would not be welcome.

There are some notorious historical figures associated with crime in Edinburgh. Burke and Hare murdered sixteen people in a period of less than two years and sold the bodies for dissection – murder being less work than grave robbing. Deacon William Brodie was a respected member of the Town Council by day, but took to night time burglary to fund his gambling and two mistresses.

The 1950s produced one murderous crime to equal those of Burke, Hare and Brodie when, in 1954, George Alexander Robertson had the doubtful honour of being the last person to be hanged in Edinburgh for the Tron Square murders.

Above: Tron Square – the location of the Tron Square murders.

Right: More than sixty years on, the postbox at the Inch displays the symbol GVIR!

Robertson was the first husband of Elizabeth McGarry – a thirty-nine-year-old single mother with two teenage children, George (eighteen) and Jean (sixteen), living at No. 57 Tron Square. Elizabeth's second marriage had finished after just a few months and Robertson came back in her life, nineteen years after they first married.

Robertson was violent and aggressive, and, after a short time, Elizabeth had thrown him out of the family home. From then on the family took measures to ensure the house was secure. However, on the night of 28 February 1954, they had neighbours round for a party and forgot to take their normal precautions.

Jean was the only person left alive to tell the story of what ensued to the High Court during Robertson's murder trial. It seems that Robertson had managed to gain entry to the house. He first attacked George with a knife. He then stabbed Jean, but was disturbed by Elizabeth leaving the house to get help. Jean tried to escape through a window, but was too badly injured. Robertson then returned to the room with the body of his ex-wife.

George made an escape – throwing himself through the window of neighbours, where he begged for help. However, Robertson ran in after George and he was killed by his father. Robertson then carried George's body home leaving a bloody trail across Tron Square. Robertson stuck his head in the gas oven, but was still alive when the police arrived.

Four months later, Robertson appeared at the High Court in Edinburgh, his guilty pleas of murder and attempted murder were rejected and a two-day trial ensued which would hear the unsettling description of his brutality. It took the jury an hour to find him guilty of killing his wife and his son and of trying to murder Jean. They had heard he suffered some kind of mad turn. He did not appeal against his death sentence and three weeks later, on 23 June 1954, he was taken from his cell at Saughton Prison and was hanged by Albert Pierrepoint at 8.02 a.m.